The
WOOD
BURN
BOOK

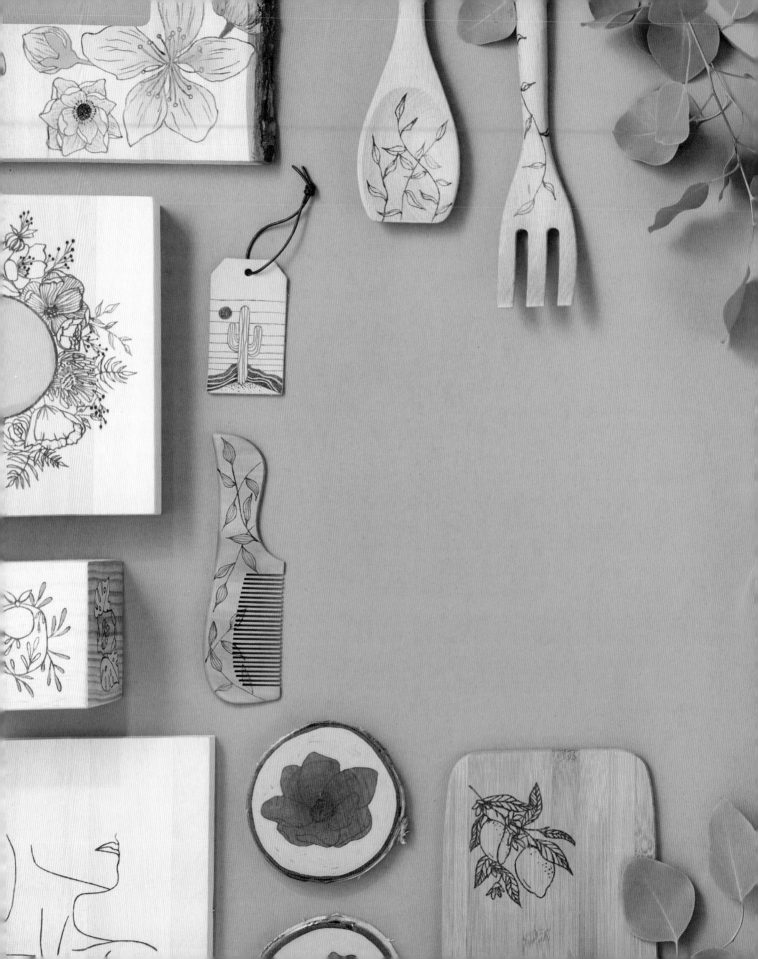

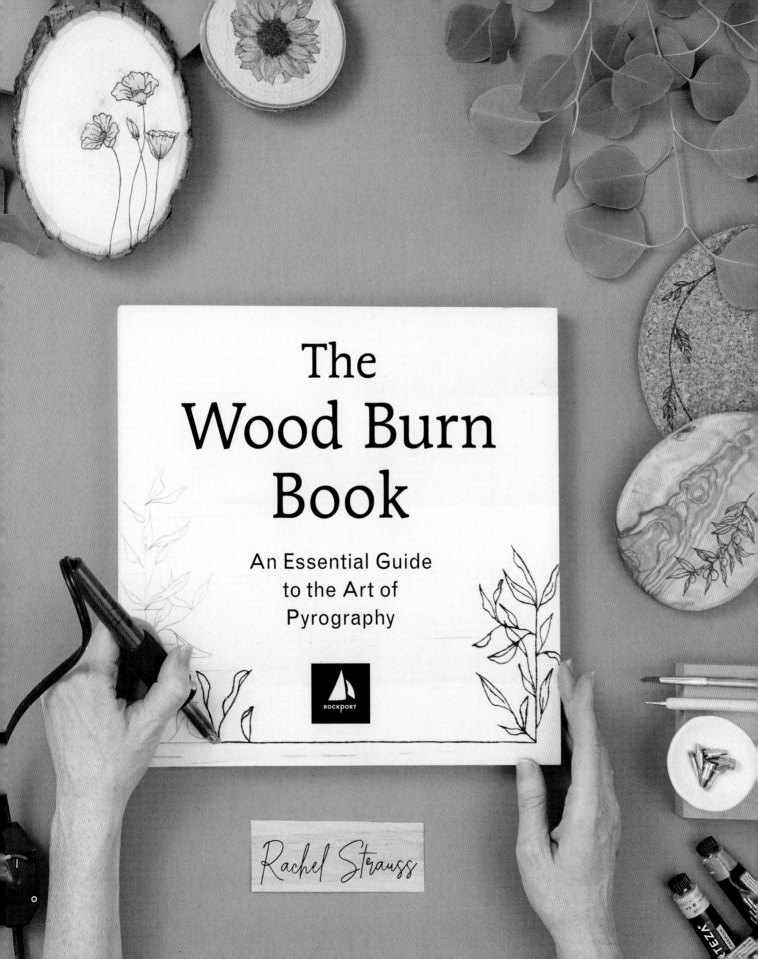

The Wood Burn Book

An Essential Guide to the Art of Pyrography

ROCKPORT

Rachel Strauss

Quarto Knows

Inspiring | Educating | Creating | Entertaining

Brimming with creative inspiration, how-to projects, and useful information to enrich your everyday life, Quarto Knows is a favorite destination for those pursuing their interests and passions. Visit our site and dig deeper with our books into your area of interest: Quarto Creates, Quarto Cooks, Quarto Homes, Quarto Lives, Quarto Drives, Quarto Explores, Quarto Gifts, or Quarto Kids.

First published in 2020
by Rockport Publishers,
an imprint of The Quarto Group,
100 Cummings Center,
Suite 265-D, Beverly, MA 01915, USA.
T (978) 282-9590 F (978) 283-2742 QuartoKnows.com

Rockport Publishers titles are also available at discount for retail, wholesale, promotional, and bulk purchase. For details, contact the Special Sales Manager by email at specialsales@quarto.com or by mail at The Quarto Group, Attn: Special Sales Manager, 100 Cummings Center, Suite 265-D, Beverly, MA 01915, USA.

10 9 8 7 6 5 4 3 2

ISBN: 978-1-63159-892-0

Digital edition published in 2020
eISBN: 978-1-63159-893-7

Library of Congress Cataloging-in-Publication Data

Names: Strauss, Rachel, author.
Title: The wood burn book : your essential guide to the art of pyrography / Rachel Strauss.
Description: Beverly, MA, USA : Rockport Publishers, 2020. | Includes bibliographical references and index. | Summary: «The Wood Burn Book teaches you everything you need to know to master the art of pyrography»-- Provided by publisher.
Identifiers: LCCN 2020005234 | ISBN 9781631598920 (trade paperback) | ISBN 9781631598937 (ebook)
Subjects: LCSH: Pyrography.
Classification: LCC TT199.8 .S77 2020 | DDC 745.51/4--dc23
LC record available at https://lccn.loc.gov/2020005234

Design: Evelin Kasikov
Photography: Lawrence De Leon
Photography styling: Bessie Lacap

Printed in China

For Abigail, Evelyn, and Isaac.
You can do hard things.

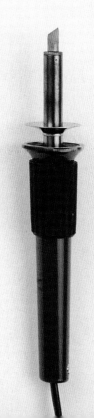

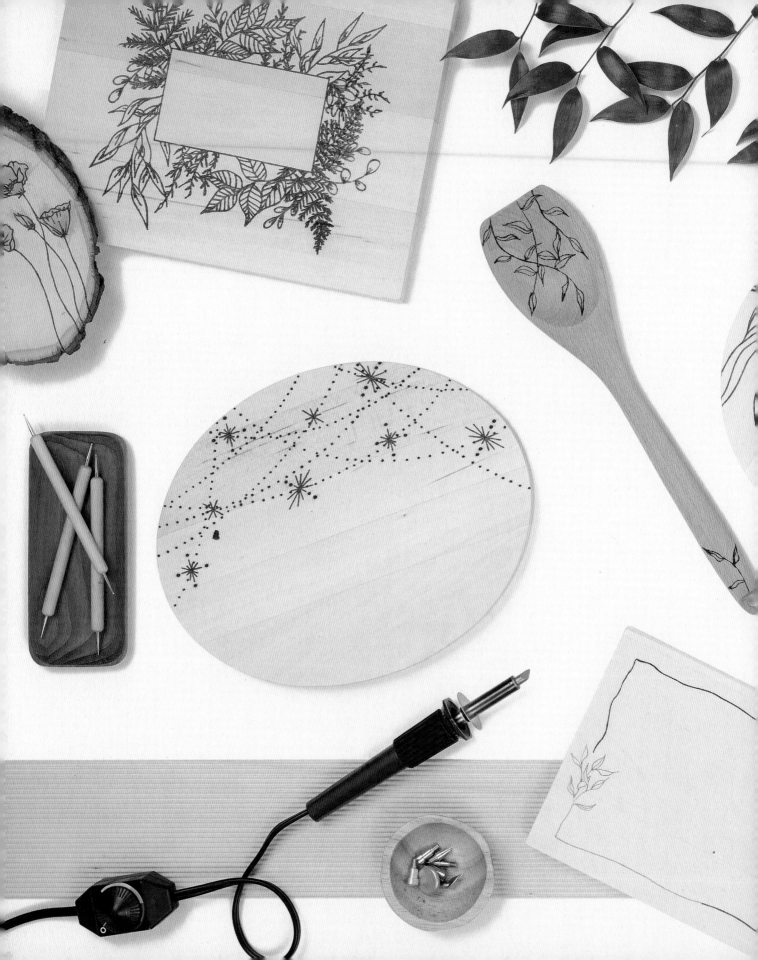

TABLE OF CONTENTS

INTRODUCTION

If you can trace, you can wood burn. Seriously. With the method I teach, and the ability to follow a line, anyone, and I mean ANYONE, can wood burn—and do it well! This book will ensure that you have all the knowledge you need to be successful at this awesome craft from the get-go.

My name is Rachel Strauss from @woodburncorner and this is the book I wish I had when I first started wood burning.

Wood burning is not my first career. I was a professional ballerina, then a Registered Nurse, then a wife and stay-at-home mom. Wood burning was never part of the plan.

I first picked up a wood burning tool when I was creating decorations for my wedding. I had been walking the aisles of my local craft store looking for some ways to create a DIY wedding to make it beautiful and personal, but still affordable. This is when I stumbled upon the wood aisle and the idea of wood burning. I bought a wood burning tool for fifteen dollars that day and whipped up a new name sign, table numbers, a cake topper, and centerpieces. They turned out beautifully, and I loved making them! It was inexpensive, fun, and the result was just what I was looking for. Mission accomplished.

I picked up that wood burning tool over the next few years to make gifts, each time enjoying the process more and more, and one day in 2016 decided to dive in all the way. This dancer, nurse, wife, and mom was about to add a new title: pyrographer.

I believe art is important.

Here's the great thing about art: it doesn't have to be perfect. Nothing created by hand is perfect, nor should it be. If you are throwing paint on a canvas, filming weird videos, singing loudly with friends, or just burning doodles on a piece of wood, you are creating, and creating is important. I want to encourage you and give you the permission to keep making regardless of the outcome, because the practice is worth more than the result.

To me, art is also about the process of making. It is about the time spent working on a piece. The concentration, the focus, the progression, the failures, the successes, and everything in between are all part of the art. Those in-between moments are where I find the most enjoyment. The finished piece is good too, don't get me wrong, but that is not why I burn. The finished piece is just the prize at the end.

I am not an artist.

I believe wholeheartedly that any inspired person who takes the time to devote to their craft is and should be called an artist. Whether that be in the medium of paint, dance, flowers, robotics, architecture, or wood burning, if you spend time creating for creating's sake, you should own that title.

You still might be thinking, that's great, but I really am not an artist. I don't have a creative bone in my body. Well, to that I say, read on, my friend. I think I might be able to convince you otherwise.

I too am not a traditional artist. I have never taken any art classes. I didn't go to art school, and I never even doodled, and yet here I am writing an art book.

You see, wood burning to me is a lot like tracing. The process that I use and teach

means that when you pick up your burner your only job will be to follow a line. Seriously. Of course, this is not your license to copy anyone else's artwork without their express permission. This book will give you all the tools you need to dive in and create stunning pieces that you can proudly hang, wear, use, or gift, and the only skill you will need is the ability to follow a line. My hope is that you will get to start benefitting from all the relaxing qualities of making art while skipping over all the frustrations of figuring it out the hard way.

Wood burning is art, and art is therapy.

It has been proven time and time again that creating art helps to improve the mental, emotional, and physical well-being of people. Wood burning is relaxing, requires patience, has an intoxicating smell, and forces the person burning to focus on the task at hand, which magnifies these benefits. By design,

wood burning is an unhurried craft, and its unhurriedness is actually part of its charm. You have to move slowly and deliberately. It is a practice in mindfulness, much like adult coloring books, but with a useable end result.

Slow crafts like wood burning have become increasingly popular, because we are purposefully choosing crafts that force us to slow down and be in the moment to escape from our busy and hectic lives. Taking this time to slowly add to a piece has always felt like time well spent.

Wood burning has a way of awakening my senses and calming my mind. It has helped me so much with anxiety, and I know it has had a positive impact on the emotional, physical, and mental health of many others. It is truly an incredible art form, and I am so excited for you to try it.

Wood burning by hand is simply the best!

There are so many aspects of wood burning that you will fall in love with. The way that the wood darkens as you burn it is mesmerizing. It has an oddly satisfying quality about it. You can play with how fast or slow this happens, which is just so cool. The smell will remind you of a campfire, and you'll notice that different woods have different smells to them. It is fascinating and so much fun. The wood pieces that you burn on all have their own character. As you work you can count the wood's rings, admire the moss, appreciate its unique shape, take note of the knots, and soak in all of its perfect imperfections. No two pieces of wood are exactly the same. Burning will connect you with nature, even if you live in the biggest of big cities. As I burn, I enjoy touching the wood to feel the slight indentation that the burn makes. I like running my fingers along the grain and wiping away any carbon that builds up as I burn, and also just checking on the progress with my sense of touch. I also find myself—and I know I am not alone in this—petting my finished pieces (just a little, not in a weird way, I promise). There is just something about feeling the depth changes of the burned parts that sends a two-dimensional piece of art into a third dimension.

Join the #BurnClub Community.

I have found that one of the best things about wood burning is the community. It is such a supportive, encouraging, helpful, and kind place. The wood burning community is already supporting your pyrography journey by offering their "Words of Wisdom" throughout this book. We believe wholeheartedly in the idea and spirit of community over competition. So, when you fall in love with this art form like we all have, I hope you join us.

Start at @woodburncorner and join Burn Club, my exclusive newsletter for wood burners of any and all skill levels. I also host challenges on Instagram for wood burning artists to push themselves and their craft and to help the community connect and grow. This community is a place for inclusion and support, and I really hope to see you there.

Be sure to share your finished pieces, tagging @woodburncorner and using #thewoodburnbook. I would love to see what you make and connect with you online. Chances are also very good you will get a re-post! I cannot wait to see what you make and how you customize it.

Happy Burning,

SAFETY

Wood burning is a very safe hobby, but there are some safety guidelines and things you can do to ensure it is safe for both you and those around you.

1. Do not leave a hot tool unattended; always turn off AND unplug the wood-burning tool when you are finished working. Always assume a wood burning tool is hot and treat it with respect. Never touch the metal parts that get hot.

2. Work on a clean, cleared off, and hard surface like a desk or table.

3. Work in a well-ventilated space. Use fans and/or fume extractors to pull the smoke away from you while you work. I also like to use an air purifier for extra security. (Position the fan right next to or over the project and facing away from you, so the smoke will be pulled away from your work area.)

4. Check the toxicity of the wood you will be using prior to burning a new piece and follow suggested guidelines. I use wood-database.com for my wood research needs.

5. Make sure the wood you choose is dried, sanded smooth, and not chemically treated or finished (meaning no stains or other finishes). It is very important to work on raw wood.

6. ALWAYS wear a mask with a rating P-95 or higher when burning. I suggest the RZ Mask 2.5M and the 3M P100 Particulate Mask. If you have long hair, always tie it up to keep it out of the way when burning.

7. Avoid getting smoke in your face by working with your head tilted to the side of the wood you are burning, not directly above it. Using a fan and goggles or safety glasses helps keep smoke out of your face and eyes.

8. Use a set of pliers and a ceramic dish for removal of hot tips. This will allow you to safely switch, remove, and temporarily discard hot tips.

9. Make sure you have a solid docking station to set the burner on while it's hot, ensuring it doesn't move around; tape your docking station to the desk if necessary.

10. Teach children about safety when your wood burning tool is in use, and never leave children unattended around your workstation.

11. Always follow all safety precautions set by the wood burning tool manufacturer. Read the directions thoroughly before use.

12. Have fun! Relax, and enjoy the process. Wood burning really is a fabulous and safe hobby.

"Avoid smoke by working at an angle."

@calliemacdesign

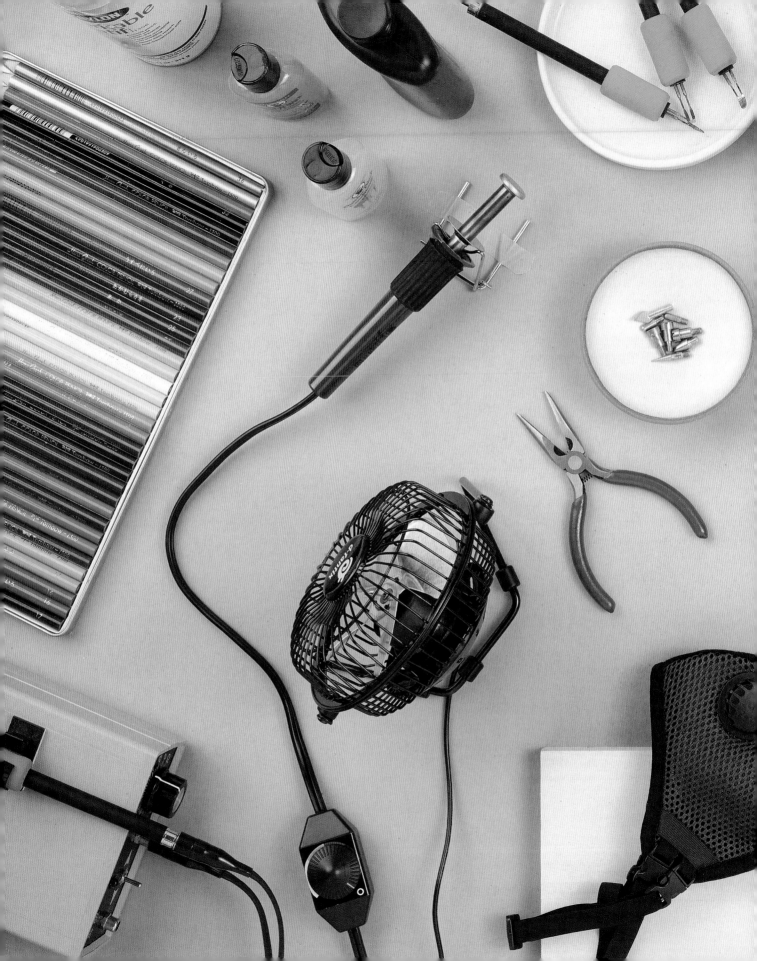

PART I:
TOOLS & TECHNIQUES

ESSENTIAL TOOLS

These are your absolute necessities, and they also just so happen to be the tools I recommend for beginners. You will want all of these tools in your toolbox, whether you are just starting out or you are a seasoned pro. They are versatile, sturdy, and oh so necessary.

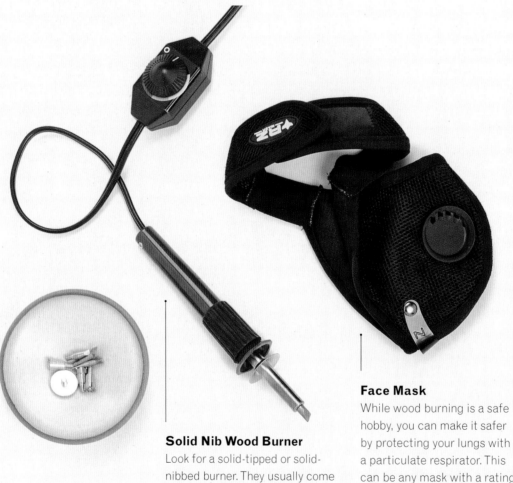

Solid Nib Wood Burner
Look for a solid-tipped or solid-nibbed burner. They usually come with a variety of nib options, are portable, inexpensive, and work really well. Be sure to choose one with temperature control. The Walnut Hollow Versatool is my recommended burner for anyone starting out.

Face Mask
While wood burning is a safe hobby, you can make it safer by protecting your lungs with a particulate respirator. This can be any mask with a rating of N95 or better, but ideally P99 or P100. I prefer an RZ mask 2.5M, because it is breathable, effective, comfortable, and easy to put on and take off.

Wood
Dried, unfinished and sanded smooth. (See page 24 for good wood options.)

Sandpaper

Sandpaper is a must in a wood burning tool box. Medium and fine grit sandpaper should be used on the wood to prepare the surface. A fine or extra fine grit sandpaper can be used to clean off any carbon build up on a solid-nibbed wood burning tool. I think if you can only choose two sandpaper grits, I recommend starting with 120 or ~~~~ or a combin~~~~

Tape

Use tape to hold down the design while transferring and to keep the wood burning docking station safely in place on the tabletop. Scotch Magic Tape is my go-to tape, because it holds well, peels up without pulling away any wood, and doesn't leave a mark. Scotch Blue Painter's Tape also works great.

Graphite Paper

There are many different ways to transfer an image or design to wood, but the one essential transfer method is graphite paper. Graphite paper is my favorite transfer option, and it's also the most widely used, and for good reason. There are some graphite papers that are messier, or that don't erase as well, so you may need to try a few out. I recommend Selizo or Saral brand graphite papers. (See page 28 for transfer techniques.)

~~~~ ser can help to remove any unwanted remaining graphite lines after the piece has been burned. Erasing those lines will clean up the look of your finished piece. While it's not perfect, the best eraser I have found for graphite on wood is the Tombow Mono Sand Eraser. A Mars Plastic eraser also works quite well.

## Embossing Tool, Pencil and/or Ballpoint Pen

This is to use with the graphite paper. If you could only choose one, I recommend a regular pencil, because you can use it either to transfer designs, or to draw directly onto the wood. I use an embossing tool for transferring, but a ballpoint pen or pencil works just as well.

# CHOOSING A BURNER

## Solid-Nib versus Wire-Nib Burners

There are two types of wood burning tools available, a solid-nib and a wire-nib burner. They vary in price, hold, how they heat, the time it takes to heat and cool, and the nib choices.

**Solid-Nib**—These are available in fixed temperature and variable temperature varieties. I highly recommend a variable temperature option like the Walnut Hollow Versatool for anyone and want to steer you away from purchasing the fixed temperature solid-nibbed burners. These solid-nibbed burners are less expensive than a wire-nib tool but are slightly harder to hold. They have a thicker grip so the placement of your hand will be farther away from the surface you are burning, but it is manageable. You will find that you will adjust to the grip quickly. These burners take several minutes to heat up and cool down. The solid-nibbed burners have no junction box, making them small and quite portable. The nibs are solid and easily screw into the burner's shaft. They can be changed while still hot, but require care, needle nose pliers, a place to drop the hot nib, and a gentle hand. For ease of nib removal, place some graphite powder in the shaft before screwing the nib into place. The wood burner docking stations are minimal so tape them down to the desktop to keep them safely in place. These solid-nibbed burners come with a variety of nibs that can accomplish any wood burning job, including shading, spade, writing, flow, and transfer nibs. Some professional wood burning artists only use these solid-nibbed wood burning tools, so don't discount the tool's abilities.

*"Get a burner with a temperature dial."*

@fandompyrography

## Sandpaper

Sandpaper is a must in a wood burning tool box. Medium and fine grit sandpaper should be used on the wood to prepare the surface. A fine or extra fine grit sandpaper can be used to clean off any carbon build up on a solid-nibbed wood burning tool. I think if you can only choose two sandpaper grits, I recommend starting with 120 and 240, or a combination sandpaper block with both medium and fine grits.

## Tape

Use tape to hold down the design while transferring and to keep the wood burning docking station safely in place on the tabletop. Scotch Magic Tape is my go-to tape, because it holds well, peels up without pulling away any wood, and doesn't leave a mark. Scotch Blue Painter's Tape also works great.

## Graphite Paper

There are many different ways to transfer an image or design to wood, but the one essential transfer method is graphite paper. Graphite paper is my favorite transfer option, and it's also the most widely used, and for good reason. There are some graphite papers that are messier, or that don't erase as well, so you may need to try a few out. I recommend Selizo or Saral brand graphite papers. (See page 28 for transfer techniques.)

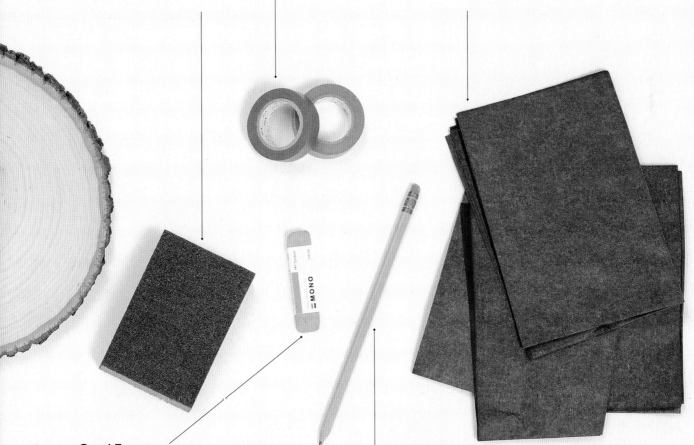

## Sand Eraser

A good eraser can help to remove any unwanted remaining graphite lines after the piece has been burned. Erasing those lines will clean up the look of your finished piece. While it's not perfect, the best eraser I have found for graphite on wood is the Tombow Mono Sand Eraser. A Mars Plastic eraser also works quite well.

## Embossing Tool, Pencil and/or Ballpoint Pen

This is to use with the graphite paper. If you could only choose one, I recommend a regular pencil, because you can use it either to transfer designs, or to draw directly onto the wood. I use an embossing tool for transferring, but a ballpoint pen or pencil works just as well.

# CHOOSING A BURNER

## Solid-Nib versus Wire-Nib Burners

There are two types of wood burning tools available, a solid-nib and a wire-nib burner. They vary in price, hold, how they heat, the time it takes to heat and cool, and the nib choices.

**Solid-Nib**—These are available in fixed temperature and variable temperature varieties. I highly recommend a variable temperature option like the Walnut Hollow Versatool for anyone and want to steer you away from purchasing the fixed temperature solid-nibbed burners. These solid-nibbed burners are less expensive than a wire-nib tool but are slightly harder to hold. They have a thicker grip so the placement of your hand will be farther away from the surface you are burning, but it is manageable. You will find that you will adjust to the grip quickly. These burners take several minutes to heat up and cool down. The solid-nibbed burners have no junction box, making them small and quite portable. The nibs are solid and easily screw into the burner's shaft. They can be changed while still hot, but require care, needle nose pliers, a place to drop the hot nib, and a gentle hand. For ease of nib removal, place some graphite powder in the shaft before screwing the nib into place. The wood burner docking stations are minimal so tape them down to the desktop to keep them safely in place. These solid-nibbed burners come with a variety of nibs that can accomplish any wood burning job, including shading, spade, writing, flow, and transfer nibs. Some professional wood burning artists only use these solid-nibbed wood burning tools, so don't discount the tool's abilities.

*"Get a burner with a temperature dial."*

@fandompyrography

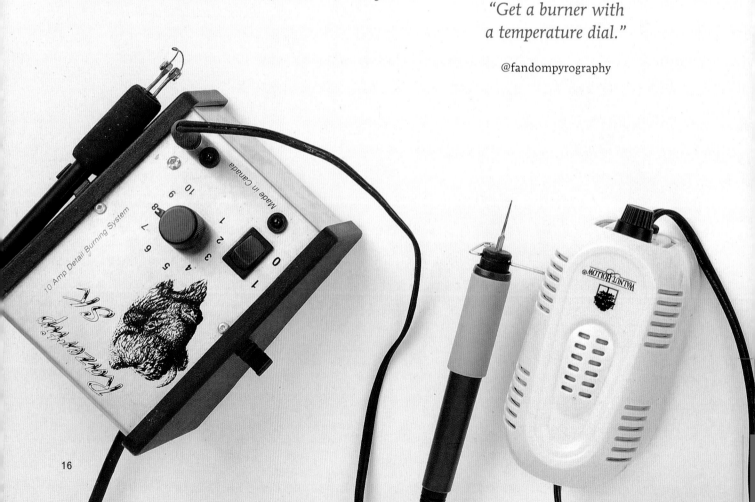

**Wire-nib**—A wire-nib burner is a wood burning tool where the heated nib is a wire instead of a solid piece of metal. These are usually called professional wood burning tools, and they tend to be more expensive. They have an easy pen-like grip. Hand placement on the tool is much closer to the surface being burned, much like how you would hold a pen or marker, and this allows for you to maintain optimal control. They heat up and cool down in seconds and have a wide temperature range that can be adjusted. Wire-nibbed burners also come with many more nib options than their solid-nibbed counterparts. Most come pre-bent and pre-molded, while some options can be purchased with pieces of wires that you can bend and mold and make your own. The one nib they do not come with is a transfer nib.

If money is not an issue, I would suggest purchasing both a solid-nibbed burner and a wire-nibbed burner. They both work great for different applications.

## Alternative Burning Methods

There are other wood burning methods and styles beyond what you'll find in these pages. Besides using a handheld wood burning tool, you can mark wood with many things, including but not limited to: a torch, a flame, a magnifying glass, Scorch Markers, chemicals mixed with heat, gun powder, or smoke. You can create negative burns, where you burn the surface and then use a relief carving technique. For the purposes of this book, however, I will be covering burning by hand with wood burning tools. Wood burning tool manufacturers vary depending on your location around the globe. You might find wood burning tools by: Walnut Hollow, Colwood, Razertip, Burnmaster, TruArt, Plaid, Weller, Tekchic, PJL Enterprises, Antex, or many others.

*"You don't need expensive equipment to create something beautiful!"*

@bridgets_burn_book

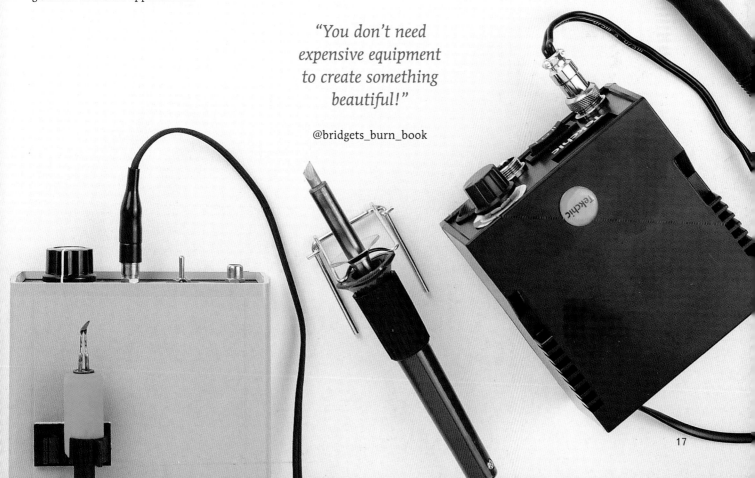

17

# Nibs and Tool Care

### Types of Nibs

There are a wide variety of nibs on the market and they all have different names depending on the manufacturer. You might also see them referred to as tips or points. In this book, I will call them nibs.

There are many different kinds of nibs for both solid-nibbed and wire-nibbed wood burning tools. Solid-nibbed burner nibs are changed simply by screwing them into the wood burning tool. With a wire-nibbed burner there are fixed-nib and replaceable-nib options. If you've selected a burner with a fixed nib, you will change the whole pen when switching nibs or if the nib wears out. By contrast, with a replaceable-nib burner, you only need to replace the nib part of the pen or just the nib's wire itself. All models have their advantages and disadvantages.

At the very least, I believe that anyone who wood burns should have a solid-nibbed, temperature-controlled wood burning tool in their toolbox—especially one with a transfer nib. No matter how good you get at wood burning, this basic tool can be used over and over again, is portable, and is versatile, coming with many different nib options. With this simple tool, you'll be able to create any wood burning project with incredible detail.

When choosing between a fixed or replaceable nib option with a wire-nib burner, you need to look at what is getting replaced or switched out when you want to change nibs. With a fixed nib option, you replace the entire pen when switching out nibs. For a replaceable nib option, there are some where just the wire is switched out and some where the wire-nib comes with its own housing and can quickly and easily be switched out. I prefer a fixed option or a replaceable option where the wire has its own housing. If you do have a replaceable wire-nibbed burner where just the wire is replaceable, to avoid temperature inconsistencies ensure that the connections are securely attached and flush against the burner. Follow the guidelines described by the manufacturer.

All nibs will need to be cleaned and securely fastened to ensure they will work properly. If you run into problems with heat, always check your connections first. Sometimes a loose nib or loose wire are to blame. If you are having trouble with a jumpy or uneven burn, cleaning your nib will usually take care of the problem.

I have divided these different nibs into categories based on how they move on the surface and the mark they leave. There is such a wide range of nibs available, and some of these nibs may fall into more than one category.

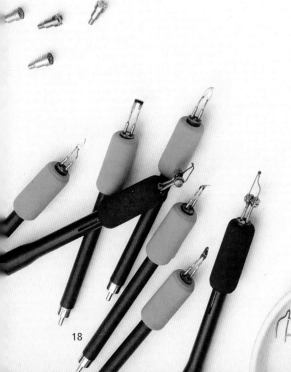

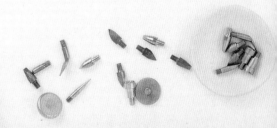

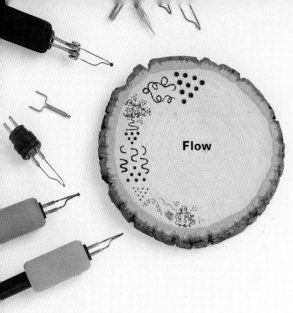

### Flow: Ball, Mini Flow, Cone, Tapered

Flow nibs are such an important and versatile nib. They are what I reach for half the time, especially with my line drawn style. These nibs allow you to easily burn in all directions without catching on edges or tips, allowing the burner to flow on the surface. It will still be easier if you pull towards you, because this allows you to better see what you are doing, but it isn't necessary with this type of nib. They are really universal—great for beginners, super smooth, and lovely to use because of their flowy abilities. I know professional wood burning artists who use flow nibs exclusively in their wood burning. Flow nibs are quite handy, but a drawback lies in their inability to fill in large areas.

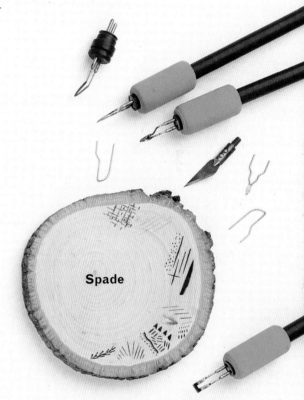

### Spade: Cutting, Skew, Spear, Chisel, Fine, Pin-Point, Rounded Skew, Blade

You can think of a spade nib like a knife. It cuts or carves into the wood. Be sure to pull these nibs towards you. If you push, you may hit the point or edge of the nib and it get stuck in the wood, leaving an over-burned spot. When using this nib, turn your wood constantly to maintain your viewing angle and allow you to keep pulling the burner towards you. This is a very useful nib, but you will need practice to get used to the feel of the edges and ends of the different spade nibs and to learn how they handle.

### Writing: Universal, Drawing, Loop, Flow, Calligraphy, Wire, Round Wire, Burnishing

Writing nibs are great to have and work fairly universally. They allow you to have precise burns, because they flow on the surface when you pull or push, similar to a flow nib, but when you move them from side to side their wider profile will drag along the surface, leaving a wider marking. This is quite useful, because it can give you the precise lines of a spade nib with the fluidity of a flow nib, but still allow you to fill in larger areas quickly. It is the perfect in-between universal nib, and if I had to choose just one nib to use all the time, this is the one I would choose.

### Shading: Spoon, Square, Pointed, Heavy, Flat, Rounded

A shading nib is used precisely for that, to add shading. They come in a variety of shapes and sizes but serve the same purpose. They are great for filling in larger areas and for adding those realistic variations in shade. You will not need this nib for the designs in this book, but it doesn't mean shading can't be added to any and all of the designs presented. My advice for shading is to turn your temperature way lower than you think you should and, while keeping your nib moving, make tiny circles. With the temperature low, you will add a little bit of burn at a time slowly making it slightly darker and darker with each pass until you have reached your desired shade of darkness. Take your time and let the shading build. This will create a really even and controlled burn.

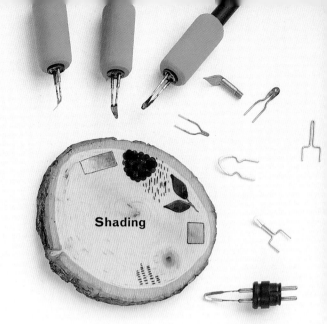

Shading

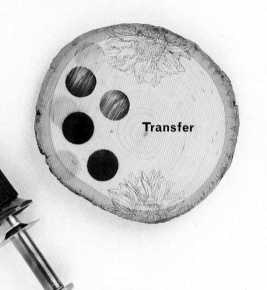

Transfer

### Transfer

There is only one transfer nib, and it is for a solid-nibbed wood burning tool. This transfer nib can be used to make large dots or fill in large areas, but they are most commonly used to transfer laser printed images to wood. This nib makes for a quick, easy, and precise transfer, and is a must-have for my toolbox. (See page 28 for transfer techniques.) I use this nib specifically for transferring lettering, precise lines, or really detailed pieces.

### Hot Stamps

Solid-nibbed burners like the Walnut Hollow Versatool come with Hot Stamps. These are little designs, numbers, or letters that can be screwed into the solid-nibbed burner and used like a mini branding iron. They burn the marking like a stamp. Simply press the hot tool directly down onto the wood, roll slightly to make sure all parts of the Hot Stamp make contact with the wood, then remove. Always practice on a piece of scrap wood to determine the heat setting and how long to hold the burner on the wood for your desired darkness.

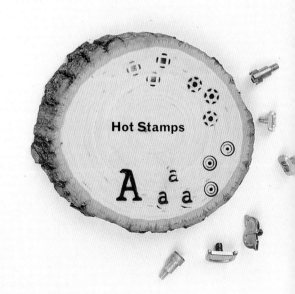

Hot Stamps

## Non-Essential Tools

These tools move into the realm of "nice to haves." I've found these to be incredibly useful while wood burning, but they certainly aren't necessary.

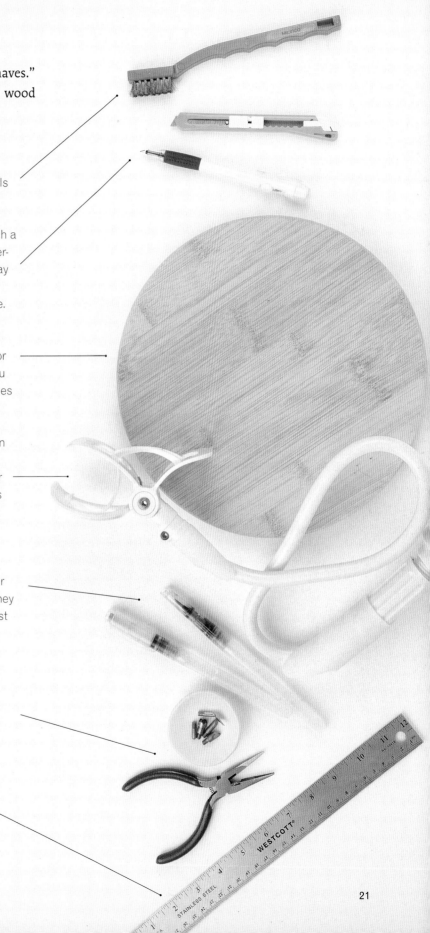

**Brass Brush**—Use this brush to clean tools while in use, giving them a quick scrape.

**Pen Razor Blade**—This little blade is such a handy tool because it helps clean up any over-burned parts in your design. Gently chip away at the burned part, and that little mistake or blemish will disappear like it was never there.

**Smooth Lazy Susan**—Place your piece on top of a Lazy Susan. This makes it easy for you to smoothly turn your piece, allowing you to continually maintain optimal viewing angles while burning.

**Gooseneck Camera Holder**— If you plan on taking any video or photos of your work, having a hands-free gooseneck phone holder is a game changer. This handy gadget makes taking videos so much easier.

**Water Brush Pens**—These are great for adding watercolor, gouache, or acrylic to your piece. They take the step of dipping your paintbrush into water out of the equation. They are fun and easy to use, and they have almost entirely replaced my regular paintbrushes.

**Ceramic Dish and Needle Nose Pliers**—These go hand-in-hand. They are used together to change nibs while they are still hot. The pliers are used to remove the nib, and a ceramic dish is used to discard the hot nib.

**Metal Ruler**—Use a metal ruler to burn straight lines directly onto the wood, no drawing necessary.

# Tool Care

The secret to a good burn is clean tools, and there are several cleaning options. Some can be cleaned while hot, while others must be done when the wood burning tool is cool. It is important to clean off the carbon build-up and char that sticks to your burner to get the smoothest and most consistent burn with less drag. It is equally important to deep clean your burners while they are cool and not in use. This will help extend the life of your burner and nibs, make them easier to clean, and allow them to perform their best.

## Brass Wire Brush

This is my tool of choice for cleaning my nibs while they are hot in the middle of a burn. I give my tools a quick but gentle brush to remove any build-up from the tool. Giving it this quick scrape will make for a much smoother burn, while not taking too much time away from the burning. This is the tool I have nearby every time I wood burn. Just be careful with your shading nibs—the brush may scratch them.

## Leather Strop with White Compound (aluminum oxide)

This is the best cleaning practice with wood burning tools to get a nicely polished nib. It is most commonly used for cleaning knives and it works really well for cleaning wood burning nibs. While the tool is cool, rub the white compound onto the rough side of the leather strop. Once the strop is fully loaded, then run your nib onto the loaded strop. The carbon/char will come right off onto the leather. Repeat as needed until the tool is clean. I have also seen some people clean their tools while they are hot with just the backside/rough side of a piece of vegetable tanned leather strop without any compound. Doing this gets the char off, without having to slow down.

> *"The best and easiest nibs to use are clean nibs."*
>
> @redroofbarnllc

## Paraffin Wax

A quick dip of the nib into solid paraffin wax while the burner is hot will melt the wax, pulling away any char with it. The wax will quickly burn off of your burner with a puff of smoke and you can get back to work with a cleaner nib. This is not my personal favorite, because I think other methods do a better job, but it does work. I learned about this method from PJL Enterprises, who make the Optima 1 wood burning tool.

## Fine Grit Sandpaper

A fine sandpaper, preferably 320 grit or higher, can be used while the burner is hot, but scrape it quickly and gently or you will burn a hole in your sandpaper. I prefer a sandpaper block, as it allows me more control in the scraping of the nib. Go easy with this technique, because it will wear down your nibs over time. Some say to never use this technique for this reason, but I have found that it works well with very little wear on my tools, especially my solid-nibbed burners.

## Damp Sponge

Some wood burning tools come with a sponge for cleaning nibs. I have found that it works well for cleaning a nib while in use, just make sure it is damp when you run your hot burner over it or you will burn the sponge.

You may also see wood burning artists cleaning their tools with tea strainers, a Dremel-style tool with a cleaning burr attachment, or with polishing cloths.

# SURFACES

## Wood

When purchasing wood, look for those that are lighter in color. Darker woods can hide your wood burned lines. My favorite woods to use are very light in color.

Some woods are quite hard, and will require hotter temperatures and more patience, while some woods are quite soft and will burn like butter. Some woods have definitive grain lines that are difficult to burn on, while others have a very uniform density and texture allowing for a very smooth burn. Some woods are more readily available, some are expensive, some come with live-edge, and some come pre-sanded. There are so many different types of wood out there and many different varieties in different parts of the world.

Some woods can be toxic to burn or handle, so be sure to look up and know the type of wood you plan to work with before getting started. Wood-database.com is a great source for this information. Never burn on MDF or pallet wood. Regardless of what wood you are using, be sure to use safety equipment to protect you and those around you while you burn.

*"Know your wood!*
*It matters!"*

@lemncusuflet

## Preparing Wood

Dried, sanded smooth, and unfinished—all three of these qualities are vital to a good burn. Having a surface that is sanded to 220 grit or greater will leave you with a smooth surface and a smoother burn. Wood must be unfinished or raw, because burning stains, chemicals, and finishes can be really bad for your health. Wood also must be dry. You will know immediately if it isn't because it will sap, hiss, and burn terribly once you apply heat. There are some wood companies that will do the prep work for you. Walnut Hollow is my preferred wood of choice for that reason. This is a really important step in the process. Do not skip over preparing your wood.

## Types of Wood

This list of top 20 wood types includes both those preferred by me and other wood burning artists in the community.

*"Basswood is a burner's best friend."*

@walnuthollow

1. **Basswood** (*Tilia Americana*) – AKA Linden or Lime tree (not the citrus). It is pale white-light brown with subtle growth rings. Knots are not very common. Widely available. My personal favorite to burn.

2. **Birch** (*Betula alleghaniensis*) – This wood is light reddish-brown in color. Found commonly as plywood and veneer, is a bit harder than basswood, is similar to maple, and is my second favorite wood.

3. **Maple** (*Acer saccharum*) – This comes in many varieties, from white to off-white to golden or even amber in color. Many can be found with straight or curly/wavy grain. It is soft and smooth and if I have to choose, it is my third favorite.

4. **Aspen** (*Populus grandidentata*) – Light white to light brown, beautiful grain, lightweight, soft, even-textured, related to Poplar.

5. **Cherry** (*Prunus serotine*) – This is a durable light reddish-brown wood with beautiful grain, and is uniform in texture.

6. **Olive Wood** (*Olea europaea*) – Yellow to light brown, with darker brown streaks. Expensive and beautiful, with a unique grain.

7. **Walnut** (*Juglans nigra*) – Medium-dark chocolate brown, durable wood, can be pricey.

8. **Yellow Poplar** (*Liriodendron tulipifera*) – Soft, pale-yellow to brown, can have green or grey hues.

9. **Rosewood** (*Dalbergia nigra*) – Richly hued, reddish-brown with darker veining and a sweet scent.

10 **Yellow Cedar** (*Cupressus nootkatensis*) or **Northern White Cedar** (*Thuja occidentalis*) – Lightweight, soft, light yellow or white to a light-reddish brown in color, even texture, fine grain.

11 **Beech** (*Fagus grandifolia*) – Pale, golden color with pink hue and speckled pattern, fine-medium grain, great for kitchenware.

12 **Ash** (*Fraxinus Americana*) – Beige to medium warm brown, coarse texture, beautiful variations in grain and color.

13 **White Pine** (*Pinus strobus*) – Pale yellow to light brown and can have red hues, not my favorite to work with, but cheap and readily available, grain and resin canals can make burning difficult.

14 **Alder** (*Alnus rubra*) – Light reddish tan-brown. Darkens with age, uniform texture, similar to birch.

15 **Sycamore** (*Platanus occidentalis*) – White-light tan, distinct freckled or spotted look, similar to maple.

16 **Peach** (*Prunus persica*) – Sweet aroma, often used for smoking meats. Smooth to burn, light tan with pink hues. Part of the cherry, rose, and apricot family.

17 **Driftwood** – Varied types of wood, shapes, and colors, washed ashore. Needs to be clean, sanitized, and dried. Won't know type of wood, so safety first.

18 **Bamboo** (*Bambusa*) – Yellow, pale hard wood, grain is straight, uniform and hard, not fantastic to burn, but inexpensive, readily available, and great for kitchenware, a strong wood.

19 **Madrone** (*Arbutus menziesii*) – Tan to pinkish brown, known for its beautiful burls, very similar to cherry, very fine grain, and even texture.

20 **Sassafras** (*Sassafras albidum*) – Light to medium brown with an orange hue, grain is coarse and has an uneven texture, also used to make root beer, very similar in look to ash.

*"Make sure your wood surface is dry and unfinished."*

@walnuthollow

## Wood Alternatives

Using a wood burning tool on surfaces other than wood can be quite fun. Think about a leather belt, cotton bag, paper card, dried gourd, or a cork coaster with pyrography embellishments. It can be a surprising way to add customization to interesting items.

Always think safety first when working with any surface. Make sure you use your safety equipment, work in a well-ventilated space, and are extra careful when burning on non-wood surfaces. Many non-wood surfaces can have quite a potent odor when burned and might be hard to handle because of their three-dimensional surface. Different surfaces require different preparation, but as a good rule of thumb, make sure your material is clean, dry, and unfinished. Use your safety gear to protect yourself and those around you while you have fun experimenting.

This is a list of some interesting non-wood surfaces that are burnable, but as I have discovered, there is no limit to what pyrographers will attempt to burn on. I have seen bananas burned with a wood burning tool, leaves, bread (toast?), marshmallows, and so many other oddball objects. I just ask that you are safe in your exploration.

*"Different wood types = different applied pressure."*

@ashenoakdesigns

In no particular order, here are some favorite wood alternative surfaces to burn on:

1. Leather
2. Cork
3. Paper
4. Gourd
5. Canvas
6. Bone
7. Antler
8. Cotton
9. Horn
10. Tree Bark

*"Explore different surfaces."*

@cgdesigns806

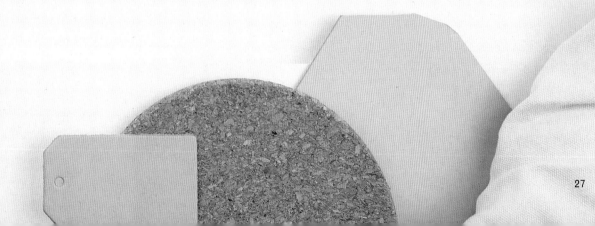

# TRANSFER
# TECHNIQUES

Transferring an image or design to wood can be done in a variety of ways. First be sure that you have permission to use the design you are transferring. You can find all the design templates from this book for your personal use at quartoknows.com/page/WoodBurnBook. Always prep your surfaces for use before transferring your image. Ensure they are dry, free of finishes, stains, dust and dirt, and are sanded smooth. The smoother the wood surface, the easier the transfer and the burn.

These transfer methods make it so you can get your design just right before you put it to wood. Many methods will allow your template to be reused easily, and many can be used for crafts beyond wood burning. Regardless of the transfer method you choose, go slow and be deliberate. Transfer just what you need to complete the design. The cleaner the transfer, the cleaner the burn.

I will cover the graphite, chaco, heat, and pencil on paper transfer methods. Avoid using carbon paper, which is often confused with graphite paper but is not the same.

For each project in this book you will see me demonstrate just one transfer technique, but for most projects there are several ways to transfer the design to the surface. If there is a specific transfer technique that works best, I will be sure to mention it. A good transfer will lead to a good burn, so knowing what to use and what to avoid will come in handy.

*"Keep a box of
patterns to reuse."*

@burning_heart_handcrafts

# Graphite

Graphite paper, a special paper with one side that is covered in graphite, is the most commonly used transfer method.

## MATERIALS

- Graphite Paper
- Design
- Embossing Tool/Pencil/Ballpoint Pen
- Tape
- Tombow Mono Sand Eraser

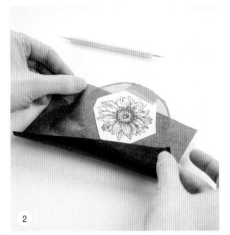

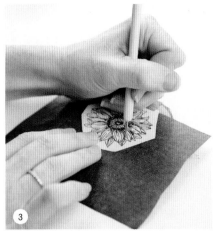

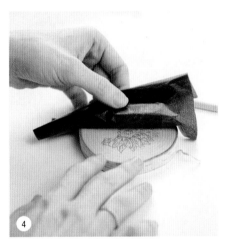

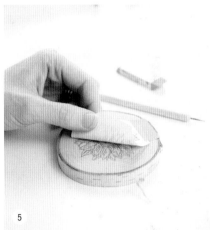

1. Print, cut, place, and tape your design to your prepared wood.

2. Slide your graphite paper, dark side facing the wood, underneath the design.

3. Follow your design lines using light-medium pressure with your embossing tool/pen/pencil. For a clean transfer and burn, follow the design lines as closely as possible.

4. Check on the progress of your design transfer by lifting a corner to peek, but do not remove the design until all has been completely transferred.

5. Once the project is complete, remove any unwanted remaining transfer markings using a Tombow Mono Sand Eraser or sandpaper.

| PRO | CON |
|---|---|
| Only need graphite paper, design, tape, and a pencil. Low cost, easy to use, and does a great job transferring even detailed designs. Graphite paper can be reused numerous times, and your designs can be used again as well. | Graphite doesn't remove easily on wood, so you have to be really careful with the transferring. Accidental smudges can happen. Store graphite away from the wood to make sure they don't rub together. |

## White Graphite for Dark Backgrounds

White graphite paper has white graphite covering one side. Use the same technique as graphite paper, but on a dark background. The darker the background, the better this method will show up. Great if you are doing torch work or relief carving.

# Blue Chaco Paper

This is a special paper with a blue chalk on one side and it erases with just water.

## MATERIALS

- Blue Chaco Paper
- Design
- Embossing Tool/Pencil/Ballpoint Pen
- Tape
- Damp Sponge

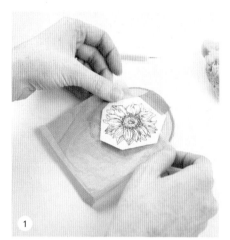

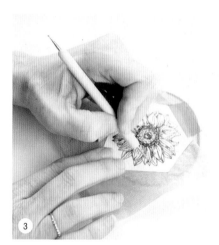

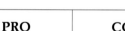

(1) Size, cut, and tape your design onto your wood.

(2) Slide the blue Chaco paper underneath with the blue side facing the wood.

(3) Follow your design lines with a light-medium pressure using an embossing tool or a ballpoint pen.

(4) Check on the progress of the transfer by lifting a corner to peek, but do not remove the design until all has been completely transferred.

(5) If you have completed your project but there are leftover blue Chaco transfer lines, simply use a lightly damp sponge or damp towel to remove any markings.

| PRO | CON |
|---|---|
| Transfers easily like graphite paper, easily removes with damp cloth. Doesn't stain/ scar wood. Can be removed entirely. Can be used over and over again. | Be careful not to use too much water when removing excess Chaco. It rubs off easily, so it is not great for long-term use. Can be a bit harder to see than graphite paper. Blue Chaco paper can be quite expensive. |

## White Chaco Paper for Dark Backgrounds

This is a Chaco paper that is white instead of blue. It works the same way as blue Chaco paper, but is great for an already darkened background, the darker the better. Just like blue Chaco paper it can be easily removed with a damp cloth. Great to use over large burned areas.

# Heat Transfer

This is a method that uses a laser/toner printed design and heat to transfer an image or design to wood.

## MATERIALS

- Laser/Toner/Photocopied Printed Design
- Solid-Nibbed Wood Burning Tool - Transfer Nib
- Safety Equipment
- Tape
- Tombow Mono Sand Eraser

1. Flip/mirror the design horizontally on computer. Print using laser printer or photocopy on a machine that has toner for ink.

2. Turn on your solid-nibbed wood burning tool with the heat transfer nib securely in place to medium-high. Wait for it to heat up.

3. Place the design on the dried, unfinished and sanded smooth wood surface, face down and secure using tape. Make sure the tape is not near the design and leave space so you will not burn the tape.

4. Pull out and put on safety equipment. Test your temperature on a piece of scrap material. Using circular motion with your wood burning tool, rub the backside of the design with your transfer nib onto the wood with hard, even pressure.

5. Carefully lift up a corner of the design to make sure everything transferred before removing the design completely.

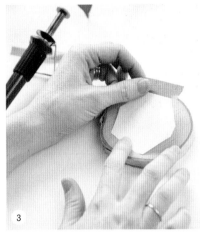

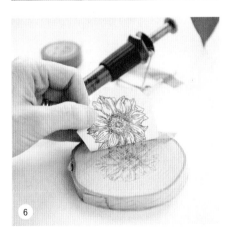

| PRO | CON |
| --- | --- |
| Fast, easy, and does an excellent job. Transfers such clean lines. Great for detailed designs and lettering. | Requires a laser printer and a hot tool. Must remember to reverse image before printing. Can lightly burn wood if you aren't careful. Grain of wood can make it transfer unevenly. Must have smooth wood surface. |

6. You shouldn't have many remaining transfer lines after you have completed your project, because this transfer method leaves such a clean transfer, but if you do, a sand eraser or sandpaper can help to remove those.

# Pencil on Paper

This method requires only the design, a pencil, and tape.

## MATERIALS

- Design
- Soft Pencil
- Tape
- Polymer Eraser or Tombow Mono Sand Eraser

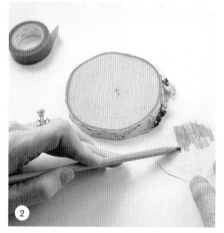

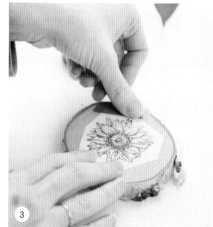

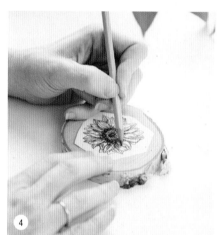

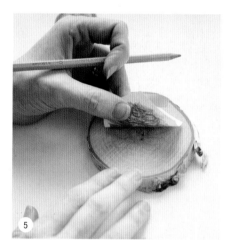

1. Take the printed design and flip it over, so you are looking at the backside.

2. Blacken/shade the entire backside of your design with an extra-soft pencil. Be sure to cover all lines that you want to transfer. Extend the shading past the lines on either side, to give yourself some wiggle room when you do the actual transfer.

3. Flip the design back over with the blackened side down, and carefully place and secure it to the wood slice. Don't rub or move it around too much, because the pencil will rub onto the wood.

4. Trace over the design carefully using medium-hard pressure. Follow your lines as closely as possible. The more precise your transfer, the better your design will look.

5. Remove the design after checking to ensure all of the lines have been transferred.

6. Once you have completed your project, you can easily remove any leftover pencil markings from your transfer with a polymer or sand eraser.

| PRO | CON |
| --- | --- |
| It doesn't require any fancy tools. It works well and makes for a nice transfer. Works for fonts and most designs. | Time consuming, messy, and it can be easy to miss spots. Not great for really fine detailed pieces. |

**SHELLY KIM**
@lettersbyshells
*Artist, Educator, Author*
Los Angeles, CA

Shelly Kim is the artist behind Letters By Shells, and she turned to art as a way to release the stress of her full-time insurance job back in 2015. Shelly has made it a mission for her artwork to express love and positivity, and for it to inspire others to believe that anything in life is totally possible. Shelly strongly believes that we all win when we support, share, and show compassion for each other. Together, we can conquer anything!

She has also taught various types of lettering workshops all over the world and is the author of two step-by-step technique card gift sets, *Learn to Create Modern Calligraphy Lettering* and *Learn to Create Art Deco Lettering* (both published by Rock Point, 2017). Shelly recently published her book, *Digital Hand Lettering and Modern Calligraphy* (also published by Quarry Books) in August 2019.

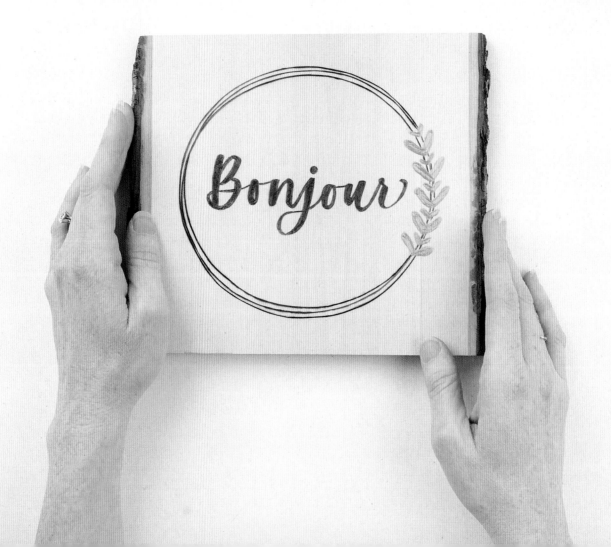

# THE PROCESS FROM START TO FINISH

This is where I will hold your hand and walk you through each step of my wood burning process. Once you learn these basics, from wood selection to actual finish, you will feel more than ready to get started. You will find yourself looking at the wood around you in a new and exciting way.

Each project you do will be slightly different, and may require different techniques, but this will be a great jumping-off point. These are the step-by-step instructions that I wish someone had shown me when I was first starting out. With these instructions in hand, you will feel confident that you too will be able to create incredible hand-burned pieces.

Because the designs in this book are all line drawings, you don't need to add shading to them to make them beautiful. Shading is a more advanced technique that I don't generally use in my designs, but I give you permission to add shading to these designs, and I encourage you to try it and see if it is for you!

## General Step-by-Step Instructions for Wood Burning

1. Choose a workspace that is clean, well-lit, cleared off, hard, flat, and in a well-ventilated space.

2. Choose design and wood piece. (See page 24 for wood recommendations.) I will be using this gorgeous hand-lettered design by @lettersbyshells, and a piece of basswood, because these are the most commonly used options in the wood burning world.

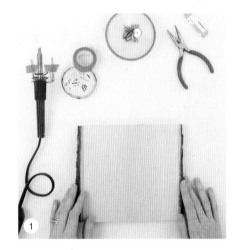

*"Always keep a scrap piece of wood nearby and use it to check your tool's temperature or tip."*

@snoozebun

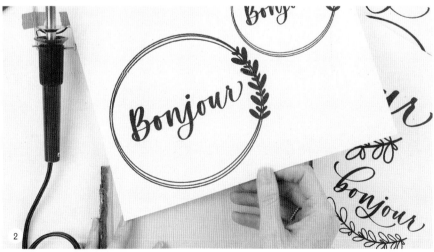

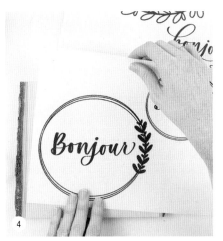

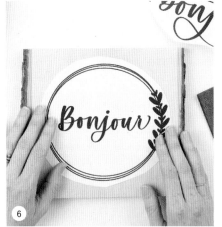

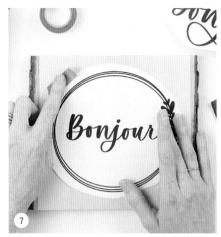

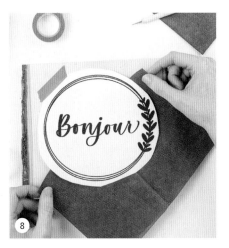

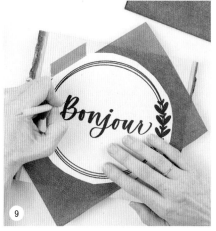

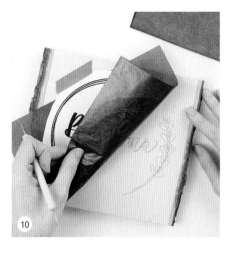

3 Sand the wood piece with a 120-220 grit sandpaper, until it is smooth. The smoother the surface, the cleaner and easier the burn will be.

4 Adjust the size of the design to fit the wood slice you have chosen.

5 Cut out the design. Try to cut evenly around the edge of the design to make placement easier. It doesn't have to be perfect.

6 Figure out how you want to orient your design on your wood piece, based on where it is going to be displayed or what photo you will

be placing in it. Then carefully place the design on the wood, making sure it looks straight. Take time on this part so it doesn't end up crooked or off-center. Sometimes it is easier to see if something is placed properly by taking a photo of it.

7 Tape the design in place on one side to allow the graphite paper to easily slide underneath. If it is a larger design, you may need to tape it down in a couple of spots.

8 Slide a piece of graphite paper underneath the entire design with the black side facing/touching the

wood. Be careful when you place it. Wherever pressure is applied, the graphite paper will transfer.

9 Using an embossing tool, pencil or ball-point pen, carefully trace the entire design with medium to light pressure. (See page 28 for transfer techniques). Wherever pressure is applied, the graphite paper will transfer to the wood. Go slow and be precise when transferring. Graphite is hard to erase, so accuracy is key. The cleaner the transfer, the better the burn. Steady hands will make for a better transfer and cleaner burn. Be sure to rest your hand

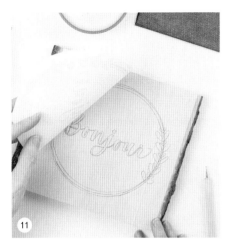

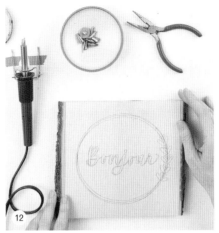

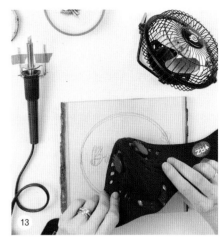

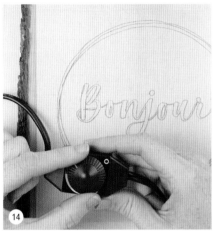

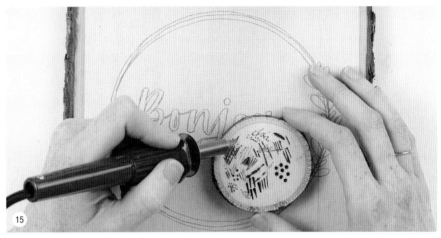

on the wood surface you are transferring to help stabilize your hand.

10 Take a peek to be sure all of the design has been transferred before removing the taped design and graphite paper from the wood.

11 When the transfer is complete, remove the design and graphite paper.

12 Choose the appropriate wood burning nib for the design and the desired burning effect. (See page 18 for nib choices.) Start

with a clean nib that is tight on the burner. (See page 22 for nib care.) Have needle nose pliers and a ceramic dish or glass jar nearby in which to place hot nibs when changing them out.

13 Follow all safety guidelines and make sure the nib, plugs, and docking station are all secure before getting started. Use safety gear to protect yourself and those around you. (See page 11 for safety.)

14 Warm up the wood burner. (See page 16 for burner options.) This can take seconds with a wire-nib or a couple of minutes with a solid-nib burner. Start with a medium heat level.

15 Test your temperature on the back side of your piece or on a scrap piece of the same type of wood to make sure you have the right temperature, and have a feel of that particular nib and burner before getting started.

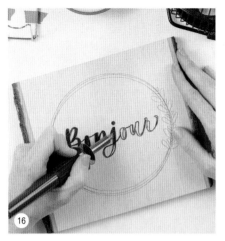

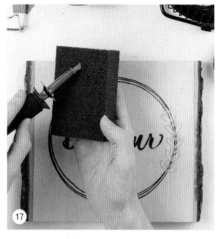

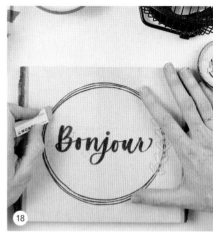

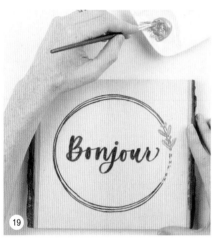

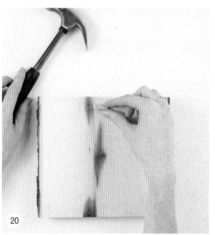

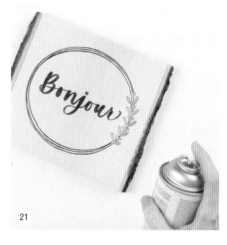

16. Start wood burning. Go slow. Pull—don't push—the burning pen. Turn your wood piece as you go to maintain an optimal viewing angle. Let the wood burner do the work for you. Let it glide on the surface while you follow your transferred lines. For a steadier burn, support your hand using your pinky or place another piece of wood next to your piece to rest and help stabilize your hand. GO SLOW. When in doubt, turn the temperature down, and go slower.

17. Keep the wood-burning pen clean. If it is not burning as smoothly as it should and the burn lines are starting to look "jumpy," give it a quick scrape with sandpaper or a brass brush to wipe off the built-up carbon. A damp sponge, fine grit sandpaper block, brass brush, or leather honing strop are all great for cleaning nibs.

18. Once burning is complete, go back over the entire piece and erase any remaining transfer lines that aren't burned over. I use a sand eraser to remove excess graphite lines.

19. Think about adding color to your piece. A pop of color can really add another dimension to a wood burned piece. Be sure to remove eraser shavings and dust off the surface before adding color. (See page 42 for color.)

20. Add a sawtooth picture hanger for easy hanging. Consider signing the back or writing a personalized note.

21. Complete the piece with an appropriate finish (see page 48) to keep it looking beautiful for a long time. For this piece I will be using a spray finish.

22. Post the finished piece to social media using #thewoodburnbook and tag @woodburncorner for a chance to have your piece featured.

# ADDING TEXTURE

Adding texture to wood burned pieces can really make the designs pop and add a whole new quality to the piece. These different texture techniques can be time-consuming, but the end result is worth the effort. Adding wood burned swirls, dots, lines, zig-zag designs, and other textural elements to a piece will add interest.

Once you know basic texturing techniques, you can add them to so many different wood burning projects. Think about adding texture to wording, backgrounds, objects, or scenery. Or use it as a shading technique or to bring depth to a piece. Textural components will draw in your eye and make you want to look at the piece longer. It will also make you want to run your hands along it.

*"Make people want to touch your work— go with high heat, deep burns, and different texture!"*

@burnedessentials

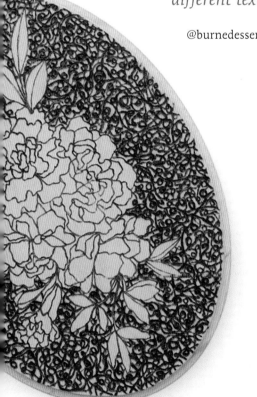

ARTIST SPOTLIGHT

**ALLI KOCH**
of @allikdesign
*Artist, Author*
Dallas, Texas

Alli K Design was founded by Alli Koch in 2014. An artist based in Dallas, Texas, Alli has turned her passion for art and design into a full-time career. The author of three published books, including *How to Draw Modern Florals*, *Florals by Hand*, and *Bloom*, she is on a mission to inspire others to create as well. You can find Alli's artwork on murals all around the Dallas-Fort Worth area and throughout the United States, as well as on merchandise in stores all around the country. When she isn't designing artwork, Alli is speaking to fellow creatives on topics such as business and entrepreneurship—whether it's on a panel or on her podcast, *Breakfast with Sis*, which she records with her Dad every Saturday morning. While Alli has been able to work with some incredible companies and created things that have been nationally recognized, her favorite part of her job is still drawing from her bed while cuddling with her cats and drinking a sweet tea.

Adding a variety of textures to Alli's beautiful floral illustration shows just how different the same piece can feel. These are just a few ways to add texture, but there really is no wrong way, and I encourage you to explore. When doing these filled in textural techniques, be sure to give your hand and your burner breaks often.

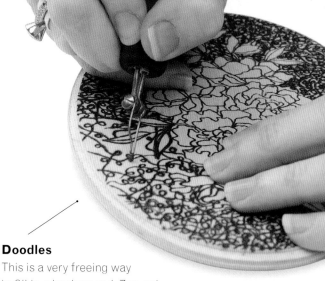

### Straight Lines

This is a visually appealing way to fill in a background. Either draw the lines freehand or use a straight edge to create perfectly straight lines. Both options are absolutely beautiful. They will make you want to stare and will surely make your design stand out.

### Doodles

This is a very freeing way to fill in a background. Zen-out and let your burner flow wherever it wants to go. I recommend using a flow nib for this type of background, because it will allow you to move your burner in all directions. Create a flow to your whole piece with your swirls or add smaller areas of interest.

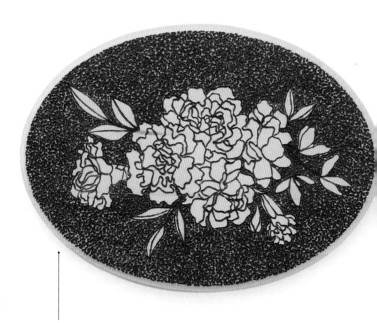

### Waves

This is a really cool technique that requires some patience, but the effect is worth it. By burning lines that aren't quite straight right up next to each other with a flow nib, you can create a wave effect. I like to start with the flow of my waves in the center of the piece and work my way out.

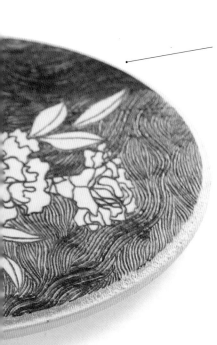

### Dots

Also known as stippling, these dots can create quite the effect and add great texture to a piece. Add them to block lettering, as shading details, or have them fade out to create a cool effect. This technique is quite time-consuming, so I recommend taking breaks to stretch out your hand when filling in a large area.

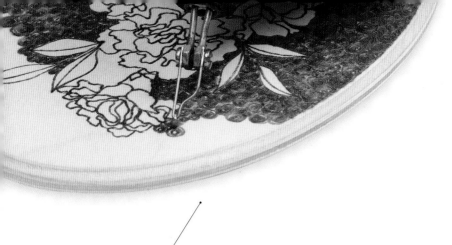

### Spirals

These little spirals or swirls are a really relaxing texture to create. You can use a flow or writing nib to create these swirling effects, but my favorite is a flow nib, which allows you to move easily in all directions. Spiral in by starting with your outer ring or start from the center and swirl out.

### Hot Stamps

Hot Stamps are nibs that can be found in many solid-nibbed burner kits. They are stamp-like nibs that leave a different marking when pressed into the wood. Use one or many different nibs to create this unique filled background. I first learned about this texture technique from @afyre_design. They use it in such a cool way.

*"High heat for
dots/stippling."*

@_burnin_vibes_

### Chevron

This is a pattern of diagonal lines that come to a point and repeat themselves. It creates a really beautiful effect when applied close together and makes the background really look three dimensional. This effect can be done with a flow, spade, or writing nib.

PANTONE®
7548

PANTONE® 16-1432
Almond

# ADDING COLOR

Adding color can bring a whole new dimension to a wood burned piece. Color can have a profound effect on any person who views it. By adding color, you can set a mood, invoke an emotion, draw the viewer's attention to certain parts, and add to a piece's overall beauty. The look of a wood burned piece can change dramatically with the addition of color. If you choose to add vibrant, muted, monochrome, dark, metallic, or light colors, you can create an entirely different piece with each.

On top of choosing the colors and tones, there are also many different color mediums available, and each provides a different quality to the project. Having a good understanding of the different color options available will help you choose the right one for the desired effect. In this next section I will directly compare nine different color options on the same type of wood (birch). This comparison will help you to better choose the right one for your project.

**Important:** All color, no matter which option you choose, MUST be added after you have burned your piece. Burning over color is toxic and should be avoided.

*"When adding color,
be purposeful."*

@burnedessentials

## Acrylic

Acrylic paint is a fabulous color option because it is so versatile and it works well on wood. Depending on how much it is diluted with water or how much thickening medium is added, an entirely different look can be achieved. Thanks to its high permanence (also known as lightfast rating), acrylic paint will remain vibrant over time, even when subject to direct lighting. It is easy to clean from hands and brushes but does not clean from clothing. Acrylic paints come in every color under the sun and can also be easily mixed to create a custom color. Once it dries, it becomes water resistant and cannot be re-animated.

**Application:** A regular paint brush or water pen works great with acrylic. Have water and paper towels nearby to clean your brush between colors or to water down your paint.

**Recommendation:** A heavy bodied, professional acrylic is a good place to start because you can build it up to be quite thick or dilute it down to act more like a watercolor. I enjoy Arteza, Liquitex, and Windsor & Newton acrylics.

## Paint Pen

Paint pens create an opaque and glossy look. They are available in acrylic or oil-based. Paint pens can come in a fairly wide variety of colors, but the options aren't as extensive as watercolor, gouache, or acrylic. Acrylic paint pens dry more quickly and have less odor than oil pens. They come in several different tip options from broad to fine-tipped.

**Application:** Shake well before use for a consistent and even color. Follow safety guidelines and work in a well-ventilated space.

**Recommendation:** Artistro Acrylic Fine-Tipped Paint Pens

## Marker

Markers provide a wide range of blendable colors in vibrant hues. Markers are a common household art pen where the ink is contained within it and distributed evenly into a porous pressed fiber material, usually felt. Markers come in a wide variety of options—waterproof, dry-erase, acid-free, water-based, wet-erase, permanent, and even washable. For use on an art project and wood, using an acid-free or archival marker is a good choice because it will last for a long time. Using a water-based marker means that you can dilute the color, mix, and/or blend colors easily.

**Application:** No need to prep the surface. To blend, you can add a second color to the tip of your marker then apply, or add one color to the wood, and then apply the next color to blend it in.

**Recommendation:** Tombow brush pens are acid-free, odorless, self-cleaning, blendable, and water-based.

## Gel Pen

The ink on a gel pen is thick, odorless, and opaque. A gel pen is a ball-point pen filled with pigment suspended in a water-based gel. It does however have the tendency to smudge more, take longer to dry, empty faster, and sometimes skip, due to the viscosity of the gel. That being said, it creates beautiful fine lines and is fairly easily controlled. Gel pens are a great option for wood, as they can add vibrant color, white highlights, accentuate burn lines, or even add a fluorescent or metallic touch to a wood burned piece.

**Application:** It works just like a pen. No prep work is necessary. Many wood burning artists will add touches of white gel pen to their photorealistic pieces in the spots where light is reflected. This really makes those white spots look more realistic. Adding black gel pen to a burned line can emphasize the line. Be careful not to smudge while still wet.

**Recommendation:** Sakura makes an excellent gel pen. To accentuate burn lines, especially on a piece that has also been painted, I like the black Paper Mate InkJoy pen.

*"The best way to learn and grow is to just try! Go for it!"*

@countrypinesshop

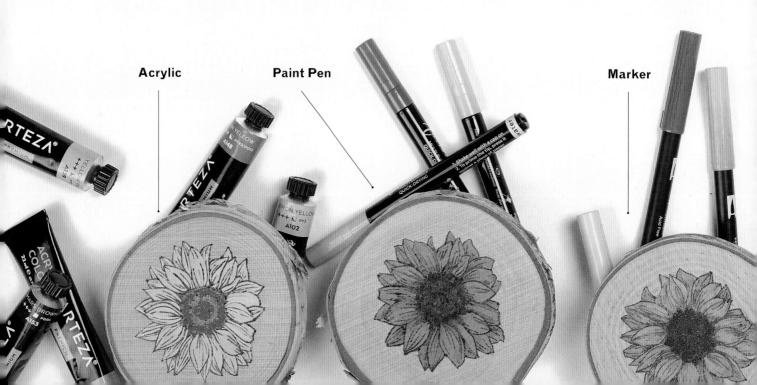

## Watercolor

Watercolors are available in a wide range of colors, are easily mixed, dry quickly, and have a matte finish. You can play with the amount of water to create different levels of vibrancy and translucency. They come in both pan and tube forms. Once dry, they can become re-animated with water. Watercolors soak in and penetrate wood well.

**Application:** A regular paintbrush or water brush pen will work great with watercolor. I suggest using a palette to mix colors. A paper plate or ceramic dish works well. Have a clean water cup and paper towels nearby. Be careful to not add too much water to your wood, which can cause the wood to expand and split or crack. To clean up any burned lines that have excess color residue, use a clean, lightly damp cotton swab or a clean, lightly damp paintbrush then pat with a clean paper towel to dry. Watercolor can spread beyond your burned lines, especially along the grain. Try using a masking fluid to keep it where you want it. I learned this trick from @northstar_pyrography.

**Recommendation:** Arteza is my preferred tube watercolor. Windsor & Newton makes great pan watercolors, but I also enjoy the more affordable watercolor pan palette by Artist's Loft.

*"Using black and white colored pencils can help create contrast when finishing a project."*

@atlasartistry1

## Colored Pencil

Colored pencils provide beautiful color with a light sheen. Colored pencil cores are usually pigment mixed with a wax or oil base set inside a wooden barrel. You can also find them in watercolor and pastel varieties. They can be layered, burnished (rubbed to a shine), blended, and sometimes erased. They are easily controlled, come in a variety of colors, and work well on wood.

**Application:** Color directly onto the wood surface. Use the color you are trying to blend, a blender pencil, a paper towel, or just rub the colors with your fingers to help them blend. You can also use alcohol or odorless mineral spirits to help blend colored pencils, but this can be more difficult.

**Recommendation:** I prefer a wax-based, acid-free, soft, professional-quality colored pencil like Arteza Expert or Prismacolor because they apply smoother, are lightfast, and blend really well.

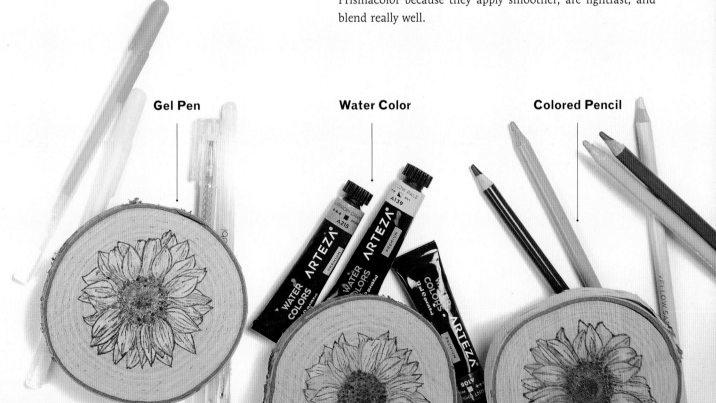

Gel Pen　　　Water Color　　　Colored Pencil

## Wood Stain

Stain adds color, protects, and provides resistance to UV degradation. Wood stain is usually water- or oil-based. You can also find stains mixed with a finishing agent like lacquer, varnish, or polyurethane. Be cautious with stains, because they can be tricky. Stains can be messy, stinky, hard to remove from hands and clothing, and are toxic to inhale, but they can create a beautiful effect on wood.

**Application:** Follow all safety guidelines listed by the manufacturer. Always test your stain on a scrap piece of the same type of wood before putting it on your project. I like to use an old paintbrush for fine details, and a rag for larger areas. Stains do have a tendency to go on unevenly or be blotchy, but applying a pre-stain wood conditioner can help with these issues. Be careful not to use a dark stain; it will make all your wood burned lines difficult to see.

**Recommendation:** Use a water-based stain. They are less messy, don't require solvents to clean from hands and brushes, and tend to go on smoother and are less blotchy. I like Unicorn SPiT for bright colors and Minwax Water Based Wood Stains for common wood colors.

## Gouache

Gouache is similar to both acrylic and watercolor. It is water-based, opaque, and matte, but becomes semi-transparent with water. It can create texture and is quite vibrant on wood. Gouache dries quickly, can be built up layer by layer, but also has the ability to be re-worked even after it has dried. Gouache is a great option on wood.

**Application:** A paintbrush or water brush pen works great with gouache. You can paint gouache on as-is or dilute it, depending on the desired effect. Just like with watercolor and watered-down acrylic, be careful not to add too much water to your wood, as it can cause the wood to split or crack.

**Recommendation:** Arteza is the only brand I use because it has so many vibrant colors.

## Chalk Marker

Chalk paint creates vibrant colors with opaque coverage. It is pigment-based, lightfast, odorless, and fun to use on wood. It goes on thick with a matte finish and applies well to pretty much any clean, dry surface. It can be found in liquid or pen form; I prefer the pen.

**Application:** Shake well before use. When starting a new pen, the pen needs to be primed. To do this, press down on the pen tip to retract it, which will draw the chalk paint down into the pen tip. Once the tip is full of color, the pen is ready for use. Apply just like a marker. Be careful not to smear. Be careful not to cover burned lines with chalk marker because it is full coverage and will obscure your burn. Should you accidentally cover some of your burn, you can clean up the chalk marker a bit with water, but it is not very easy.

**Recommendation:** Choose your chalk markers based on color and size of the tip; I prefer fine or medium-tipped markers. Craft Smart or Liquid Chalk markers are the ones I use.

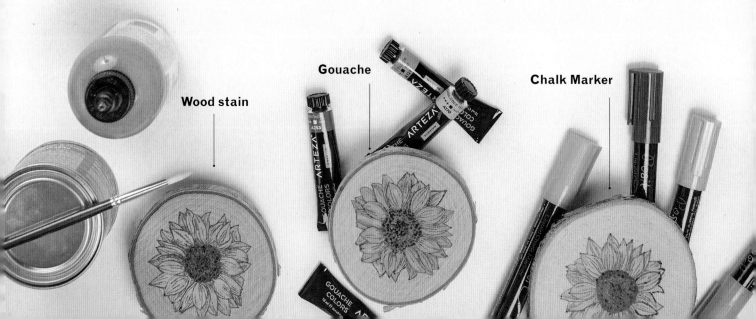

**Wood stain**

**Gouache**

**Chalk Marker**

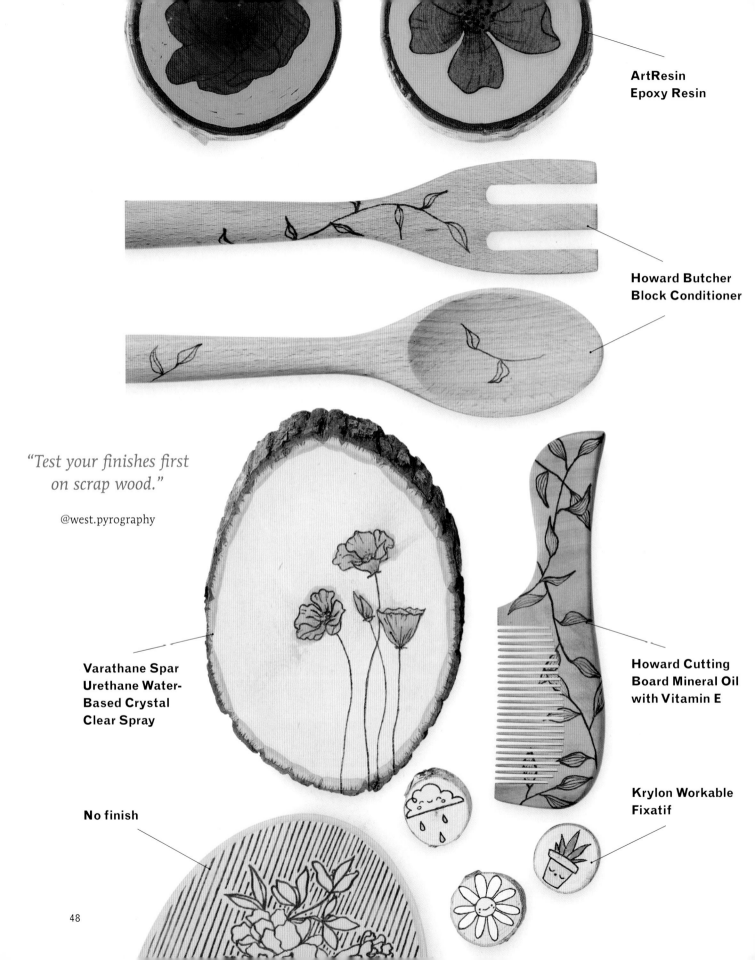

**ArtResin Epoxy Resin**

**Howard Butcher Block Conditioner**

*"Test your finishes first on scrap wood."*

@west.pyrography

**Varathane Spar Urethane Water-Based Crystal Clear Spray**

**Howard Cutting Board Mineral Oil with Vitamin E**

**Krylon Workable Fixatif**

**No finish**

# FINISHES

When choosing the right finish for your project, there are a few things you should consider:

- Time
- Cost
- Use
- Desired Effect

Some finishes are ready almost immediately while others can take days to cure. Some finishes are quite inexpensive while others are a little more costly. Will your item be used with food? Will children be playing with the item? Do you want it shiny or matte?

There are so many schools of thought and preferences out there when it comes to finishing wood burned pieces. I will be covering what I have found to be the best and most commonly used finishes in the wood burning community.

For each project in this book, I will use one specific finish, but please use this chart and wood reference to help you choose a finish of your liking for your particular project and its use.

There are many other wood finishes including Danish oil, tung oil, boiled linseed oil, and grapeseed oil that you may see other wood burning artists using. I personally don't use them because after trying and comparing them all, I find those listed in the chart on pages 50 and 51 to be better options.

*"Never attempt to apply oil-based sealant on top of water-based sealant."*

@jrwoodburnings

| Name | No Finish | Cutting Board Oil/Mineral Oil | Board Cream/ Butcher Block Conditioner/ Mineral Oil and Beeswax | Polycrylic |
|---|---|---|---|---|
| What is it? | Raw: the wood as is. | A liquid, usually mineral oil stabilized with Vitamin E, this finish is odorless, colorless, and food safe. | A semi-liquid to solid mix usually comprised of mineral oil and non-bleached beeswax, and carnauba wax, depending on brand. | Water-based, this finish comes in matte, satin, gloss, and high gloss sheens in addition to spray or brush-on forms. |
| Application | – | Apply with cloth to clean, dry wood surface. Allow to soak in for 20 minutes. Remove excess. Apply 2 coats. | Apply to surface with clean cloth or paper towel along grain. Allow to soak in for at least 20 minutes or overnight and remove any excess cream. | Spray or apply thin layer with a synthetic bristle brush or sponge brush. Allow to dry for 2 hours, sand with fine grit (220), remove dust and apply another coat. |
| Drying/ Cure Time | – | 40 minutes for 2 coats. | For best results 12 hours, minimum 20 minutes. | 3 hours for light handling, 24 hours before normal use. |
| Food safe | Yes, depending on wood | Yes | Yes | No |
| Cost $–$$$$ | – | $ | $ | $$ |
| Durability | Does not provide any protection against bumps, scratches, UV light, or water except the wood's natural durability. | Protects wood from cracking and drying out. Soaks deep into the wood to moisturize. | Oil penetrates the wood, while the wax protects the surface. Mineral oil protects from cracking and drying out by moisturizing, and the wax creates a water-resistant sealer that protects surface. | Protective top coat. Resists damage from abrasion, scuffing, chipping, and water. |
| Color | Wood will be natural color. | Does not change color, enhances grain slightly. | Enhances color and adds warmth. | Crystal clear, doesn't change color. |
| Rachel's Notes | *Wood will be dry and lighter in color than with any finish. It will have a greater contrast to the burn because of the sanded particles on the surface and the dry nature of the wood slice. It will not be protected from UV rays, fingerprints, and dust or grime.* | *Apply two coats. Give it time to soak in. Very easy clean up. It soaks in well and won't leave a film once soaked in completely.* | *This can leave the surface waxy, attracting dirt and dust. Best for cutting boards and kitchen utensils. Be aware it will enhance the wood grain but will darken any imperfections/spots/knots in the wood.* | *I choose spray polycrylic when there is any color added. Spray several coats. With brush-on form, be aware that spreading the liquid with a brush can cause colors to bleed, depending on media.*<br><br>*Polycrylic is thin in viscosity and dries quickly, so use a sponge brush to eliminate some brush strokes in the finished piece. Be careful not to apply too thick or it can become milky in color.*<br><br>*The higher the sheen, the more protection from fingerprints.* |

| Workable Fixatif | Refined Coconut Oil | Polyurethane | Resin | Mod Podge |
|---|---|---|---|---|
| This aerosol spray finish is matte, clear, and durable. It protects artwork as an archival spray. | Oil that is solid at room temperature, liquid when slightly above room temperature. | Comes in water-based or oil-based varieties. Water-based is preferred. Spray or brush-on. | A two-part mixture of resin and hardener. High-gloss, epoxy resin. | A decoupage medium, all-in-one glue, sealer and finish. Matte to gloss sheen varieties. |
| Shake can vigorously, then apply several thin coats in sweeping fashion in a well-ventilated area on clean surface. | Apply melted oil to clean, dry surface with clean cloth. Allow to soak in for 15 minutes, then remove excess. | For water-based, spray evenly 10–12 inches (25–30 cm) from surface. For liquid brush on, apply with sponge brush. | Must be mixed in equal proportions, must be applied right away, and will self-level. | Apply with sponge brush to clean and dry surface. |
| 10–15 minutes, can handle after 1 hour. | 15 minutes | Dries to touch in 30 minutes. | Dries after 24 hours, fully cured after 72 hours. | 48 hours for full cure, dry within a couple hours. |
| No | Yes | No | Yes, when fully cured | No |
| $ | $ | $$$ | $$$$ | $ |
| Protects but allows for re-working of colors. | Moisturizes wood and protects surface. Water-repellant. | Provides some UV protection, water resistance, mold and mildew resistance. Four coats are recommended for best durability. Second only to resin in durability. | Very durable, dries hard, water-proof, scratch resistant | Seals and protects wood, water-resistant. |
| Does not change color, non-yellowing. | Does not change color. Will enhance natural wood color. | Crystal clear but may yellow wood over time. Oil-based is more yellow in color. | Crystal clear, will darken wood, and may yellow over a long period of time. | Goes on opaque, but dries clear and doesn't change wood color. |
| *Many people use this to hold or set colored pieces before applying a different finish. It also works great on its own.*<br><br>*With this finish you have the ability to add more color later.* | *Readily available in grocery stores, this finish is cheap and works well. Be sure to buy refined coconut oil, or it can go rancid, and nobody wants that.* | *Water-based is less smelly but still stinkier than polycrylic. Can cause wood to yellow over time. I prefer to use a sponge brush to eliminate brush strokes in the finished look.* | *Can be messy. Because it's self-leveling, it will spill over sides, so be prepared. Set your piece up on a smaller block, so it won't get stuck on your surface, pour it over the piece, spread the resin out to evenly coat, then use a flame to pop any bubbles while resin is still wet. Simply run the flame just above the surface until bubbles pop. @alyoopsartistry taught me to add a layer of isolation coat first to prevent resin from soaking into the wood and becoming uneven.* | *Used often to seal bark on live edge pieces. Great for mixed media pieces on wood. Dries quickly and will show brush strokes. Use a bright light at an angle to see brush strokes while wet.* |

## Finishes Comparison

Being able to compare different finishes and how they work over different color mediums is incredibly helpful in choosing the right finish. You don't want to end up ruining a piece in its final step. Trust me, that is infuriating. This board will help you avoid just that.

You can see how the different finishes affect the wood, the burned parts, and the different colors applied. With this board of my favorite finishes, you can see how oils spread beyond where they are applied—even beyond the burned lines—and how mod podge leaves brush stroke marks. You can see how chalk marker spreads with almost every type of finish and which finishes accentuate and enhance colors. You can also see how the burned parts are affected and how the wood changes with the application of a finish. My hope is that this is a page you visit often and that it saves a couple pieces from ending up in the bin.

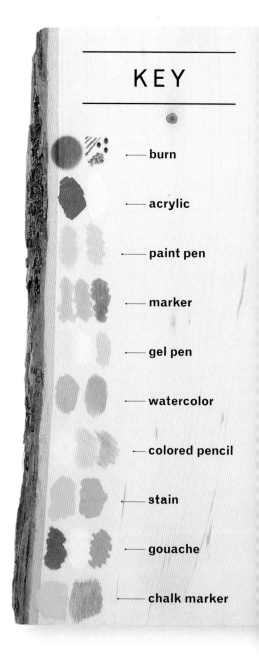

## KEY

— burn

— acrylic

— paint pen

— marker

— gel pen

— watercolor

— colored pencil

— stain

— gouache

— chalk marker

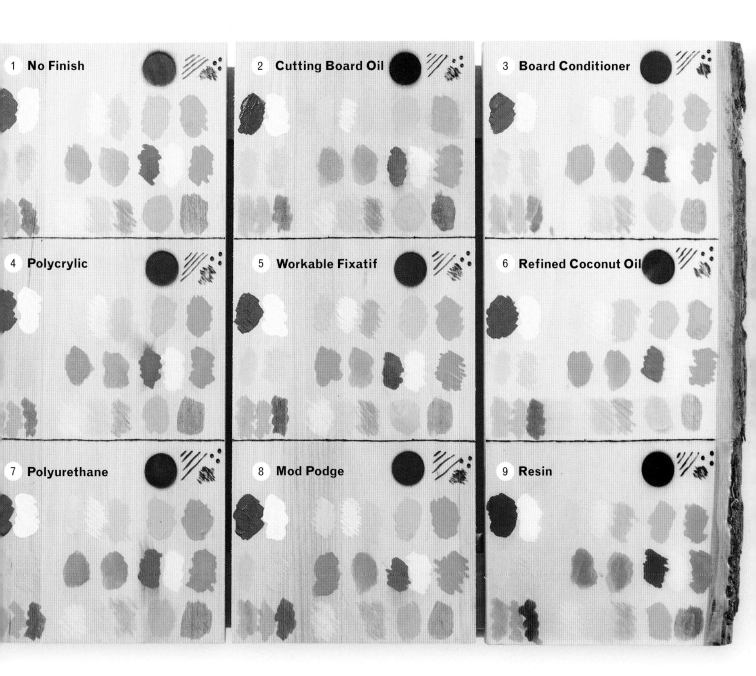

1 **No Finish**

2 **Cutting Board Oil**

3 **Board Conditioner**

4 **Polycrylic**

5 **Workable Fixatif**

6 **Refined Coconut Oil**

7 **Polyurethane**

8 **Mod Podge**

9 **Resin**

# PART II:
# PROJECTS & INSPIRATION

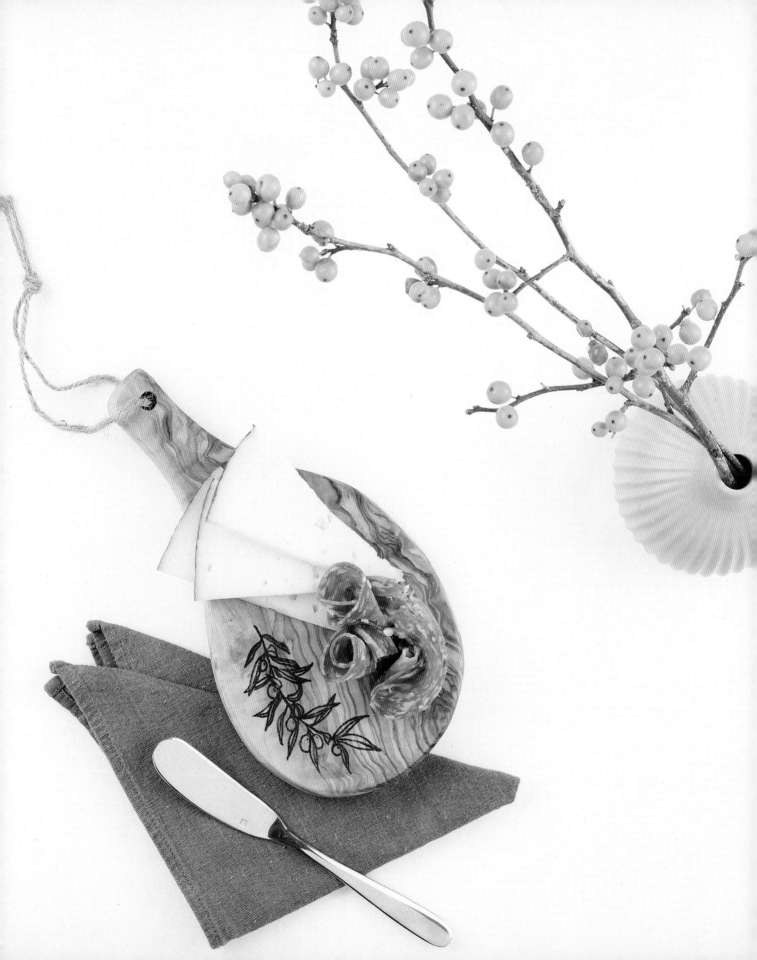

# Serving Board

## *Burning Olive Wood*

**MATERIALS**

- Wood Serving Board
- Design
- Transfer Supplies
- Safety Equipment
- Wood Burning Tool + Flow,
  Spade, or Writing Nib
- Food-safe Finish

Olive wood is such a gorgeous wood to burn. Even though the color varies throughout the wood grain, olive wood burns fairly smoothly, making it a favorite with wood burning artists. You may find olive wood commonly used in kitchenwares. Olive wood is a fancier wood, and adding some wood burned touches to this already fancy wood will give you all the Martha Stewart vibes. Stepping up your hosting game just got so much easier.

*"Don't get caught up worrying about mistakes; that's what sandpaper is for!"*

@somethingrhedey

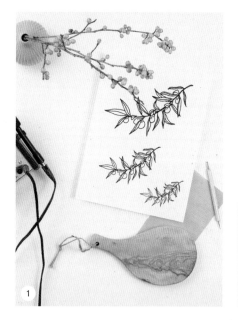

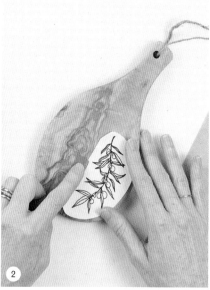

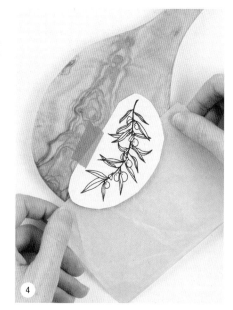

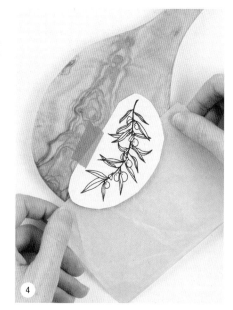

1. Choose a wood serving board.
I will be using this gorgeous
olive wood serving board.
Ensure it is dry, sanded smooth,
and unfinished.

2. Choose your design, and size it to
your wooden board.

3. Cut, place, and tape your design
in your desired location on the
wooden board. I will be using the
Chaco paper transfer method
for this tutorial. (See page 28 for
transfer techniques.)

4. Slide your Chaco paper under the
design, with the blue side facing
the wood.

5. Trace your design using the
embossing tool or ballpoint pen.

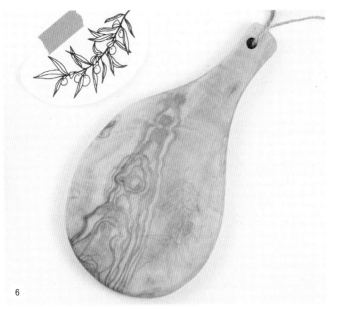

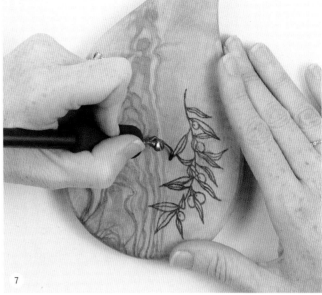

6

7

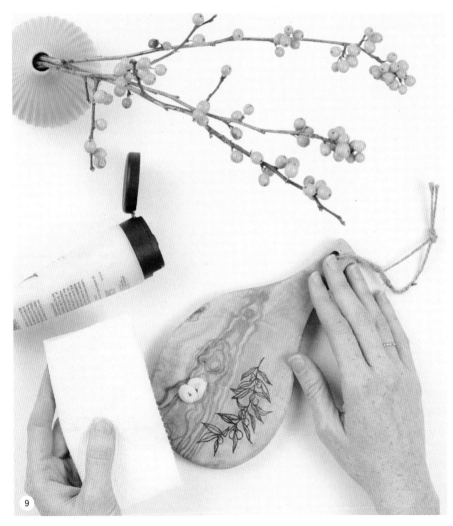

9

6   Once transferred, remove the design and Chaco paper. Pull out your wood burning tool and nib of choice. Ensure you have a clean nib. (See page 14 for wood burning tools and page 18 for nibs.)

7   Warm up your burner, test your temperature on a scrap piece of wood, and then start wood burning. Go slow and take your time. Use your pinky or another piece of wood of the same thickness to rest and steady your hand.

8   Remove any remaining transfer lines.

9   Apply a food-safe finish to your wood burned serving tray to keep it looking beautiful for a long time.

Find design templates at quartoknows.com/page/ WoodBurnBook

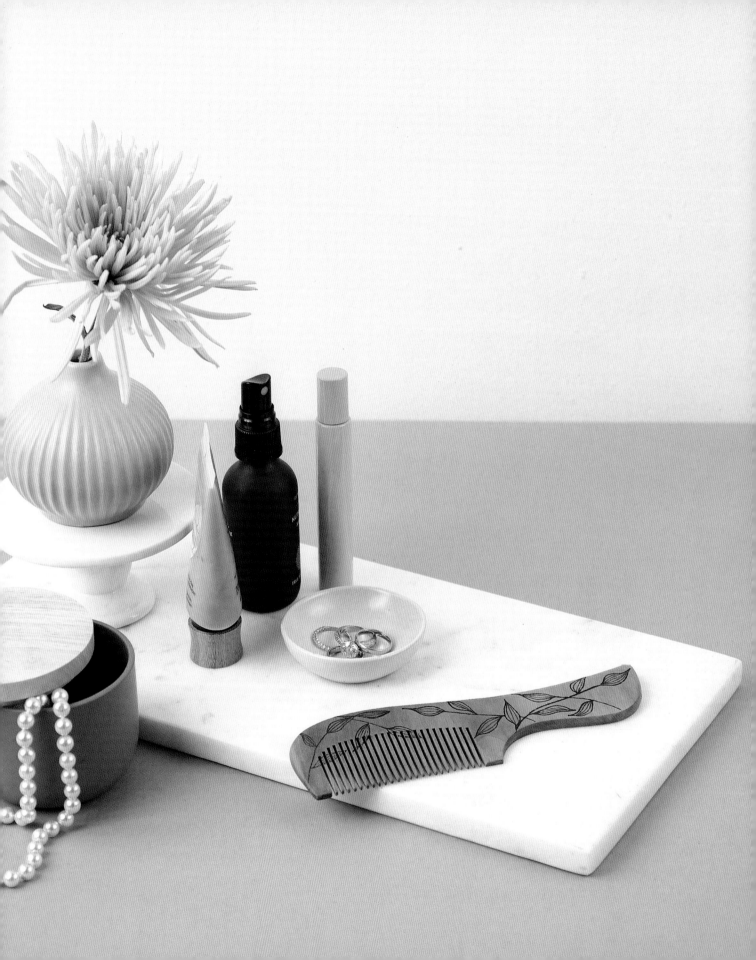

# Botanical Wooden Comb

*Burning Peach Wood*

## MATERIALS

- Wooden Comb
- Sandpaper
- No. 2 Pencil
- Safety Equipment
- Wood Burning Tool + Flow,
  Spade, or Writing Nib
- Finish

Peach wood is such a lovely wood to burn. It is baby smooth, has a rich color, smells amazing, and looks so gorgeous when burned. Adding wood burned touches to these wooden combs will make them look so beautiful and will make you want to brush your hair all the time! You'll want to leave this functional piece of art right on the counter, because it is so pretty.

I know you didn't think you would have to draw, but I promise you can totally handle this. Easily create this simple design from scratch, burn on a three-dimensional surface, and try your hand at burning on peach wood with this elegant hand burned comb. It makes an excellent gift and I encourage you to add personalized touches.

*"Let the burner do the work!*
*Just guide it!"*

@spiritfireburns

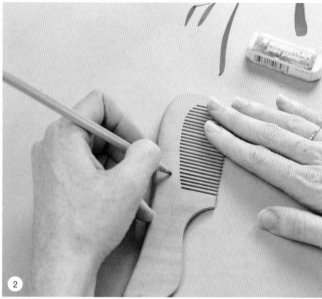

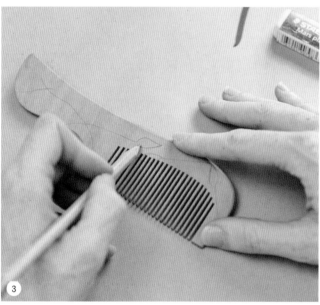

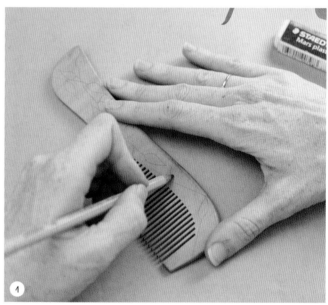

1. Sand your unfinished wooden comb until it is smooth. I am using a peach wood comb for this project.

2. Use a pencil to draw vines and stems onto the comb. Draw them in all different directions and leave space to add the leaf shape.

3. Draw a large leaf on the end of each stem.

4. Fill in the rest with leaves running down the stems, alternating left and right. Extend the design onto the teeth of the comb. It doesn't need to be perfect, because nature isn't, but try to make the leaves roughly the same size and shape. Draw all the leaves onto your stems.

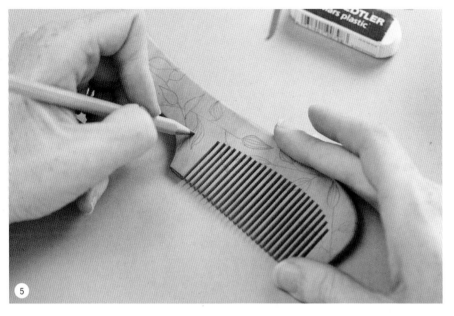

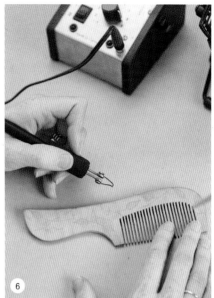

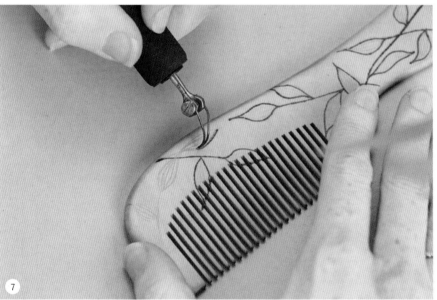

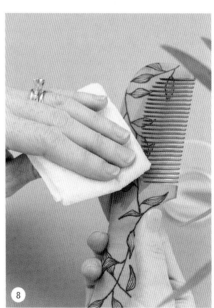

5 Draw veins down the length of each leaf. Start at one end of the leaf and draw a line towards the other. Curving the lines to match the curve of the leaf, try to fit 3 to 5 lines per leaf.

6 Once your design is complete, choose your nib, secure it, and warm up your burner to test your temperature. I recommend a flow, spade, or writing nib.

7 Start wood burning. Go slow. Use your pinky finger to stabilize your hand and be mindful of your holding hand. Since a comb is an odd shape, you will have to change your grip often.

8 Add a finish that is safe for hand/hair use to your comb to moisturize it. I will be using a mineral oil. (See page 48 for finishes.)

*"Choose your finish based on what the piece will be used for."*

@kirstyangove_art

# Mud Cloth Centerpieces

## *Burning Birch*

**MATERIALS**

- Wood Round
- Design
- Sandpaper
- Safety Equipment
- Wood Burning Tool + Flow, Spade and/or Writing Nib
- Transfer Supplies
- Finish

Birch wood is another favorite in the wood burning world. It is a harder wood but makes for a really smooth and beautiful burn. This particular birch slice has a natural bark edge, which is paper like, has beautiful color variations, and is just so pretty to look at. This makes the perfect centerpiece for any table.

This mud cloth inspired design will look great with a candle or some flowers placed on top. Step up your table décor with this handmade, and hand-burned birch slice.

*"If using a small piece of wood that you can't lean on, use a second piece of wood that's the same height to steady your wrist."*

@craftedandburned

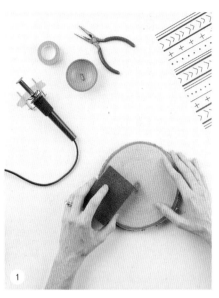

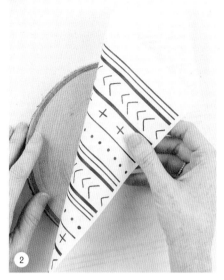

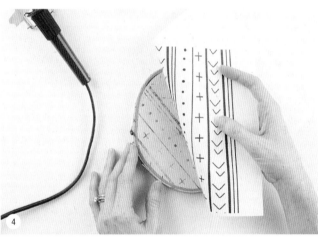

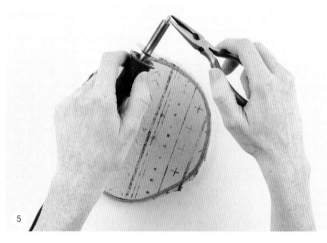

1. Choose the design and wood slice. Make sure the slice is dried and sanded smooth. I will be using a birch round for this project with a live edge. (See page 24 for wood recommendations.)

2. Print the design using a laser printer and place the design face down onto the wood slice to prepare for transfer. I will be using a heat transfer method for this particular project. There are other transfer options if you do not have a transfer nib (see page 28 for transfer techniques.)

3. Transfer the design to the wood. I will be using the hot tool with transfer nib. Warm up the solid-nib burner with the transfer nib securely in place. Make circles to avoid burning too much in one spot and apply hard, even pressure when using the transfer nib.

4. Check to ensure all of the design has been transferred before turning off the burner and removing the design.

5. Switch out the nib. (See page 18 for nib options.) Remove the transfer nib and apply the nib of your choosing to burn the design. Have a ceramic dish and needle nose pliers handy to make this switch possible while the burner is still warm. Always turn your burner off when changing nibs.

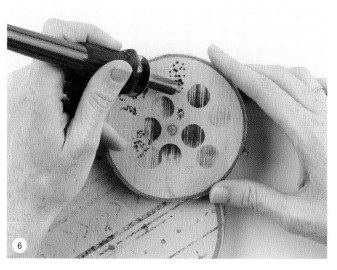

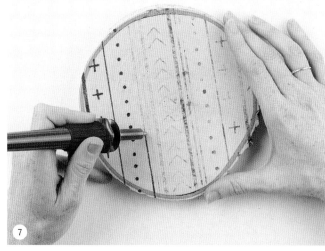

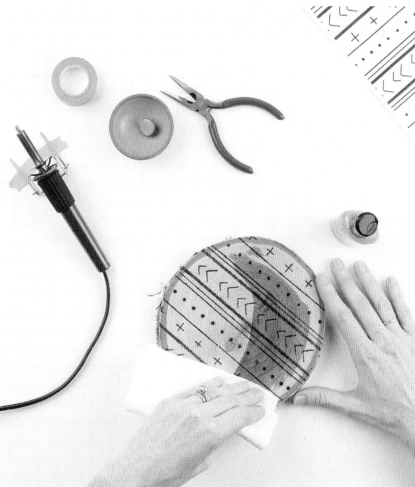

6. Reheat the burner and test your temperature on a scrap piece of birch or on the back of your wood slice.

7. Follow your transferred lines with your wood burning tool. Use a slow and steady hand. Remember to pull, don't push.

8. Remove any remaining transfer lines once burning is complete. I will be using a sand eraser for this.

9. Apply a finish. (See page 48 for finishes.)

10. Wait for the piece to dry fully before adding to your table décor.

**Find design templates at quartoknows.com/page/ WoodBurnBook**

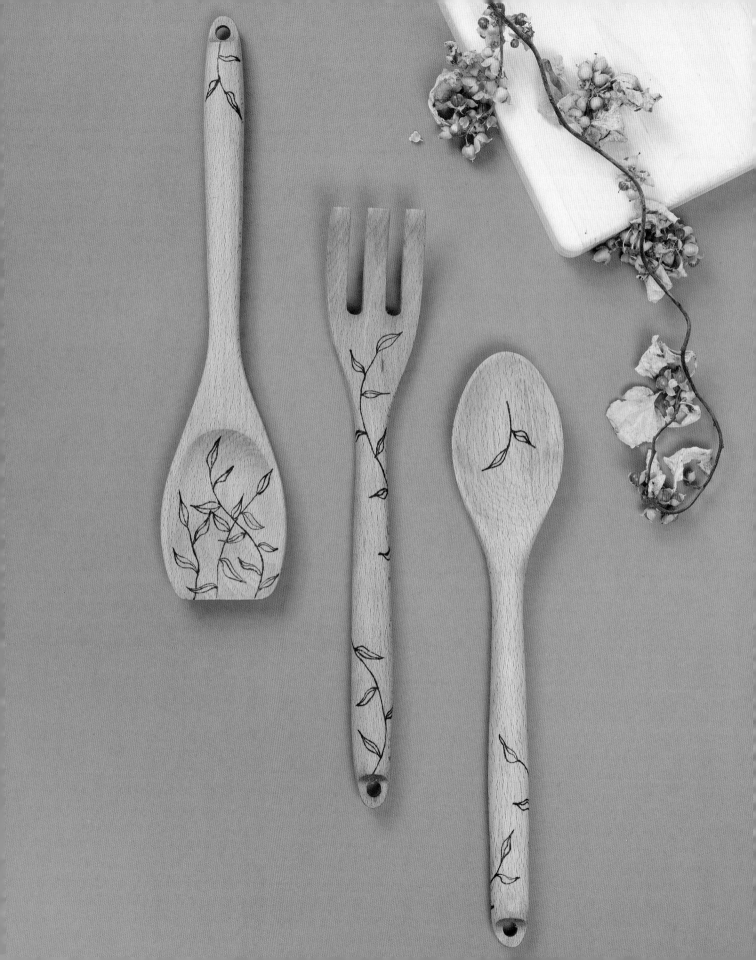

# Freehand Wooden Spoon

*Burning Beechwood*

**MATERIALS**

- Wooden Utensil
- Sandpaper
- Soap and Water
- Pencil
- Safety Equipment
- Wood Burning Tool + Flow, Spade or Writing Nib
- Food-safe Finish

Beechwood burns really cleanly and smoothly, making it an excellent choice for a wood burned utensil project. This easy-to-replicate spoon with a freehand leafy design not only looks wonderful, it's functional, and a useable gift is always a welcomed choice. In fact, these hand-burned cooking utensils are so lovely that the recipient may even say they are too pretty to use!

This design is simple and can be modified to fit your particular utensil and style. Using this simple drawing technique, you can create very different looks. The design can wind down from the handle, sit only in the scoop of the spoon, or maybe on the backside. I give you permission to explore and make it your own. You can create your own version of this gorgeous utensil set that is cohesive, beautiful, and functional!

*"Keep pencil or transfer markings light. Trust me!"*

@redroofbarnllc

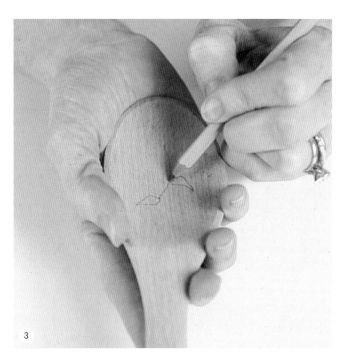

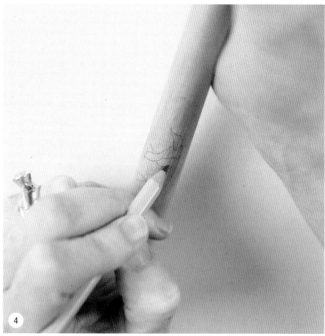

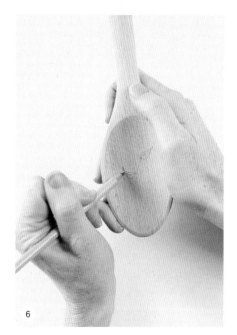

1. Prepare your unfinished utensil by sanding it smooth. Wash it with soap and water and allow to dry thoroughly. I will be using beechwood utensils for this project.

2. Use a pencil and carefully draw the basic shape of the vines onto the spoon. This is just a simple wavy line that will become the vine. It can be long, short, curvy, or straight, and can have multiple branches. Get creative with this, but don't draw on the wood too hard. Use gentle pressure to leave a slight marking. This will make clean up and mistakes much easier to correct

3. Once the vines are laid out, start adding the leaves. Create an elongated leaf shape alternating between the right and left sides of the vine, with one occasionally growing straight up the vine. I tend to start my leaf with a point and end with a point. What happens between the two points should fluctuate. Try to make the leaves similar in length, but do not worry about them being perfect. You can change up the look of the entire piece by making all the leaves larger or smaller, fatter or skinnier.

4. If two leaves are going to cross paths, one will be a complete leaf in the foreground or on top, while the other will be in the background, disappearing behind the main leaf. If you are having trouble drawing the background/bottom leaf, lightly draw it over the other leaf fully, and then erase the parts that would be hidden behind the top/foreground leaf.

5. Continue to fill in leaves until the vine is as full as you'd like. It is OK to erase and try again.

6. Draw lines down the length of the leaves. This will give the leaves their character. This line doesn't have to be centered or perfect. Nature isn't perfect, and leaves shouldn't be either. The more variation, the more realistic it will appear.

7. Pull out your burner and nib of choice. (See page 18 for nib options.) Warm up your burner and pull out safety gear.

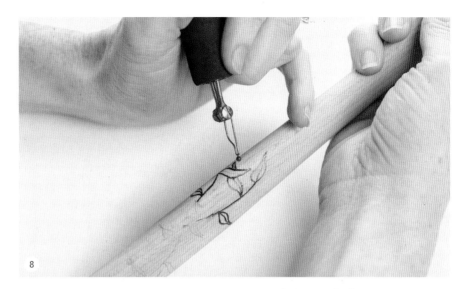

8. Follow your pencil lines with the burner. Go slow and steady. Burning on a wooden spoon can be a bit awkward. Use your pinky finger on your burning hand to help stabilize your hand to the utensil. Holding the spoon steady against the working surface with your other hand will help.

9. Erase any remaining pencil markings once the burning is complete, then wash with soap and water and let the spoon dry completely.

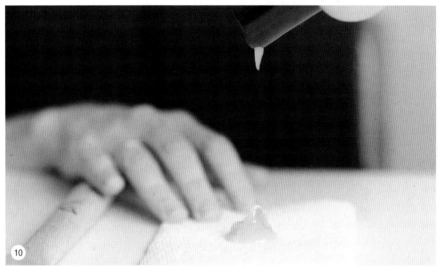

10. Apply a food-safe finish to your spoon (see page 48 for finishes). To keep it looking nice for years to come, do not wash the utensil in the dishwasher and reapply finish as needed. When giving a hand burned spoon as a gift, consider writing up a care card to remind the recipient to not put it in the dishwasher and to reapply the finish on occasion.

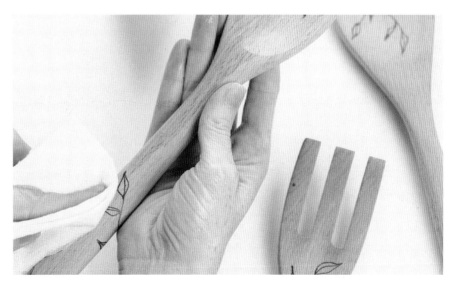

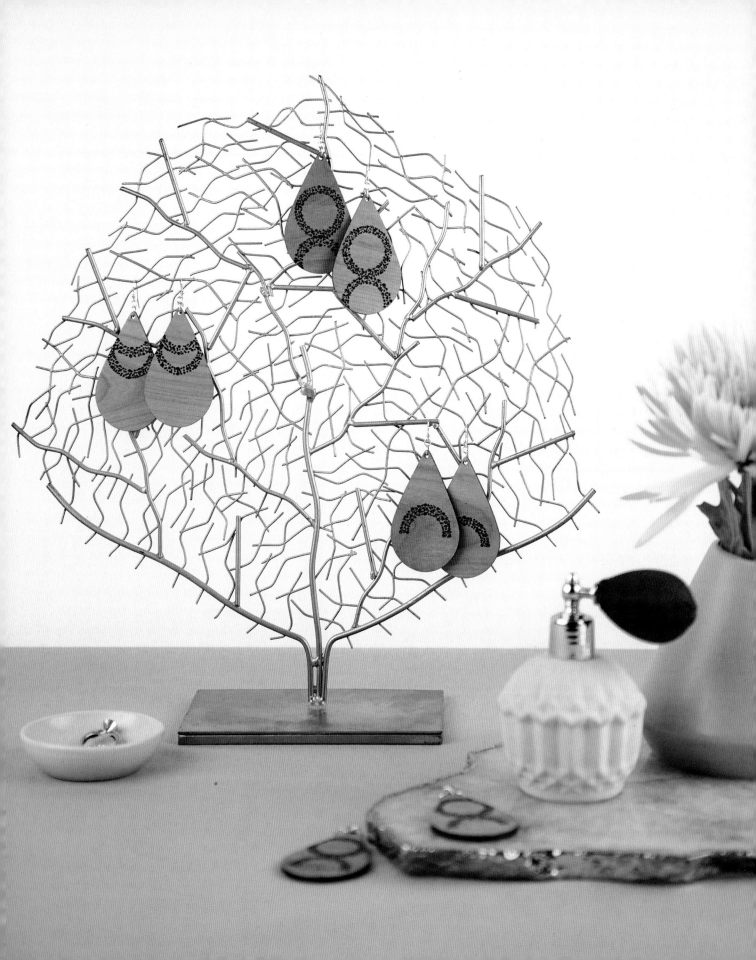

# Wood Earrings

*Burning Cherry Wood*

## MATERIALS

- Wood Earring Blanks
- Wood slice
- Tape
- 4 mm Closed Jump Ring
- 6 mm Open Jump Ring
- Fishhook Ear Wires
- Safety Equipment
- Wood Burning Tool + Flow or Writing Nib
- Coins
- Needle Nose Pliers
- Finish

Cherry is such a beautiful and accessible wood. It has a naturally gorgeous, warm color to it, and it burns and smells so good. I used cherry wooden earring blanks to create these hand-burned pieces of wearable art with just a little time, a few dots, and a couple of coins. Look for earring blanks at craft stores or online in a variety of shapes and sizes.

Using coins as a stencil, you can create this graphic and textural effect that will make your earrings stand out. These dramatic earrings will go with almost any outfit, are lightweight, inexpensive, and make for such a gorgeous gift.

*"Experiment often!"*

@completelydevoted_designs

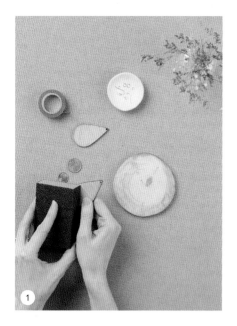

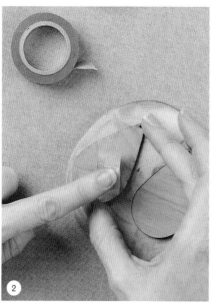

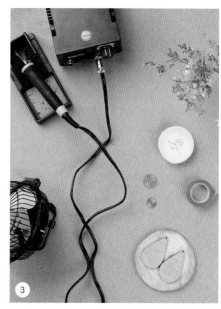

1. Prepare the unfinished wood earring blanks. Ensure they are dried and sanded smooth. I am using cherry wood to create these earrings.

2. Tape the backside of your earrings to a larger piece of wood to make them easier to handle.

3. Choose your nib, attach it, and heat up your burner. For this particular design, I will be using a flow nib with a ballpoint tip. (See page 18 for nib selection.)

4. Place a coin or coins on the wood in the desired location. Tape the backside of the coin to hold it in place on the wood.

5. Use your wood burning tool to add dots around the perimeter of the coin(s). You can burn right next to the coin to use it as a stencil.

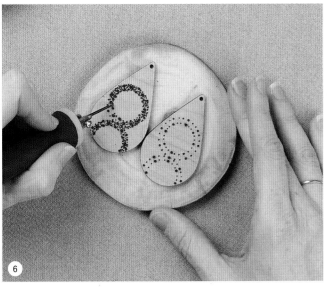

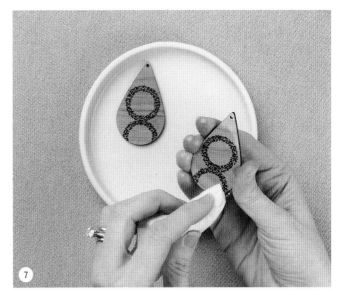

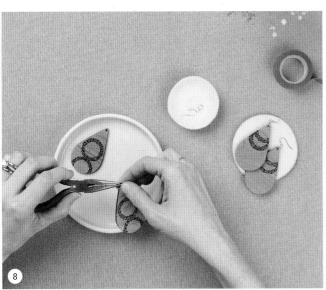

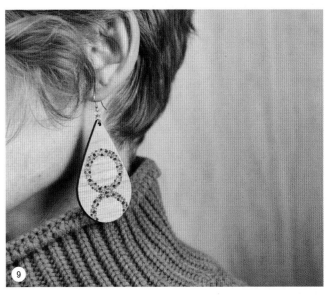

6 Once the perimeter is in place, remove your coin(s) and start adding a stippled or dotted effect (see page 40 for other ways to add texture). Use your creativity here to make it your own. Add three coins, fill the entire background with dots, or have the dots fade.

7 Add a finish to bring out that gorgeous cherry wood grain. I will be adding a wood conditioner. (See page 48 for finishes.)

8 Using a pair of needle nose pliers, twist open the 6 mm open jump ring and insert it through the hole in the wood, add the 4 mm closed jump ring, and close the open jump ring to secure the two rings to the wood burned piece.

9 Grab your fishhook ear wires and slide the small closed jump ring onto the hook. Secure it in place by pinching the opening closed. You now have a new pair of earrings! Slide them onto your ears and get ready for your day of compliments.

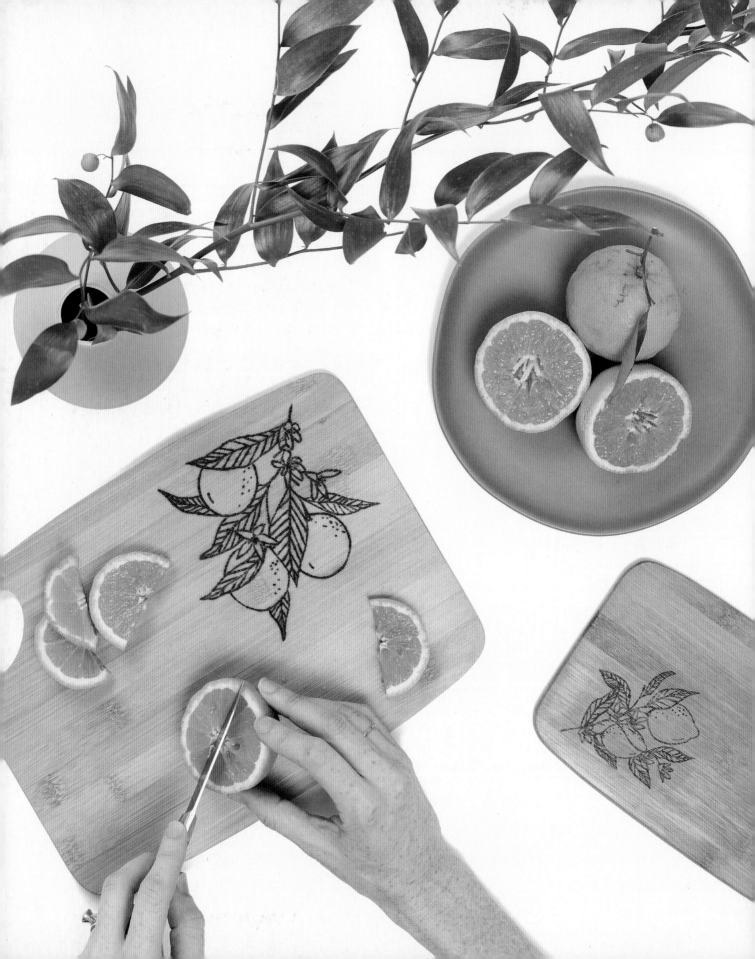

# Fruity Cutting Board

## *Burning Bamboo*

## MATERIALS

- Wooden Cutting Board
- Design
- Sandpaper
- Transfer Supplies
- Safety Equipment
- Wood Burning Tool + Flow, Spade, or Writing Nib
- Food-safe Finish

Customizing cutting boards is fantastic because the end result is beautiful art that you can actually use. And who doesn't love functional art? Bamboo's dense and fibrous nature is what makes it such a good cutting board choice, but these traits actually make it slightly more difficult to burn. Don't worry, it's worth it.

Wood burned touches added to a cutting board made of inexpensive and sustainable bamboo will make it so much better. A beautiful hand burned cutting board will seriously step up any chopping experience. Guaranteed.

*"Long strokes burn much easier if you follow the direction of the wood grain."*

@sheepianna1

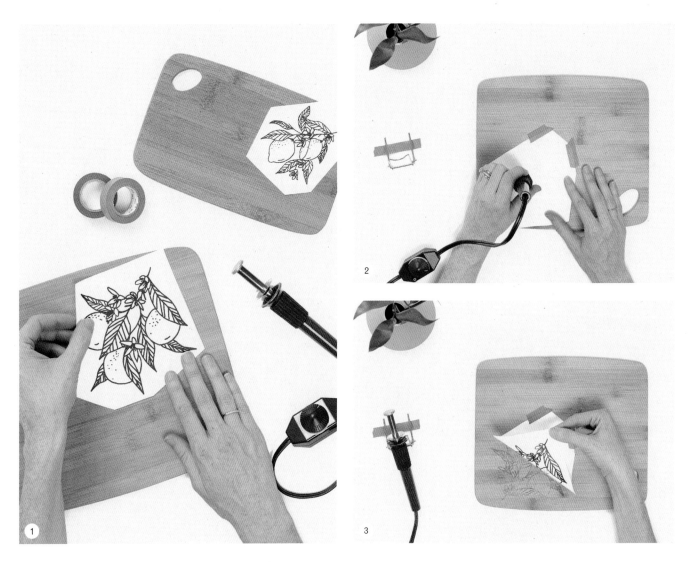

1 Sand the wood smooth and wipe it free of dust. This will help with your transfer and with the burning. Bamboo is ideal for use as a cutting board, but it is a difficult wood to burn because of its hardness and inconsistencies in grain, so sanding it really well will help. Size the design to fit the wood.

2 Blue Chaco, heat, or a graphite transfer will work well for this project. I am using the heat transfer method for this tutorial. (See page 28 for transfer techniques.) For a heat transfer, you will want to print the design in reverse, especially for lettering, using standard computer paper and a laser printer. Cut out the design then tape it in position with the ink side facing the wood.

3 Using a wood burning tool and transfer nib warmed up to medium or high heat, work in a quick circular motion to rub the backside of the entire design with hard, even pressure. Move quickly to avoid scorching the wood in any one spot. Check to make sure the design transferred completely before removing the paper.

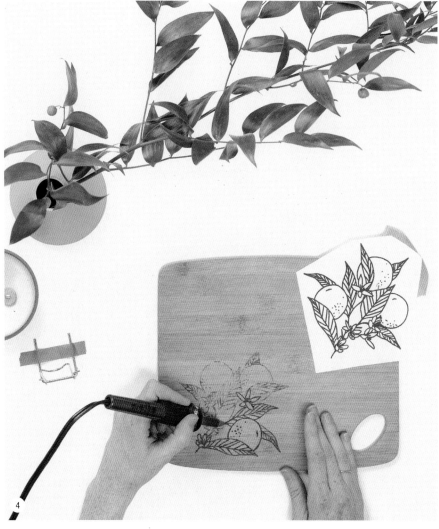

4. Turn off your burner and, carefully using pliers and a ceramic dish, set aside the transfer nib. Replace it with a flow, spade, or writing nib. Follow the transferred lines with the wood burning tool. Bamboo is a hard wood and needs more heat to burn. If possible, always test temperatures on a scrap piece of the same type of wood. Clean your tool often to keep your lines sharp.

5. Once complete, wash with soap and water and allow to dry completely before finishing your hand burned cutting board with a food-safe oil finish. This will make any drab cutting board fab. (See page 50 for finish recommendations.)

6. When giving a wooden cutting board as a gift, consider writing up a care card so the lucky recipient can keep the cutting board looking beautiful for a long, long time. Wooden cutting boards should not go in the dishwasher, and they need to be conditioned on occasion with a food-safe oil to keep them looking beautiful.

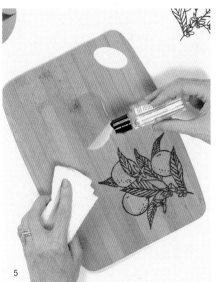

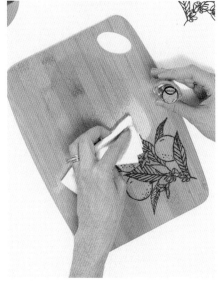

Find design templates at quartoknows.com/page/ WoodBurnBook

# Line Drawn Silhouette Art

## Burning Basswood

**MATERIALS**

- Wood Canvas
- Digital Photo
- Printer
- Pen or Fine-Tipped Marker
- Sandpaper
- Transfer Supplies
- Safety Equipment
- Wood Burning Tool + Flow or Writing Nib
- Picture Hanger
- Finish

This gorgeous design is created on basswood, which is my absolute favorite type of wood to burn on, because it is beautiful, soft, light in color, and doesn't tend to have a lot of imperfections or hard grain lines. It makes for such a smooth and beautiful burn. This simple design on basswood looks and feels like fine art. Using this technique, a quick photograph can be easily turned into a personal fine art piece. The beauty of it lies in the fact that it takes minutes to create, is drawn entirely from a photo, and even though it looks like fine art, it doesn't come with that fine art price tag.

Once you know how to create it, there are endless possibilities. Think about a gorgeous wood burned drawing of your favorite muscular back, delicate hand, chubby baby leg, or strong jawline. Each new subject, angle, position, or body part has the potential to become a new one-of-a-kind piece. Have tons of fun exploring and playing with this technique.

*"Do not keep burned art in direct sunlight. Burns fade."*

@photo_journal_girl

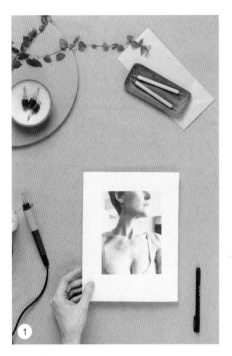

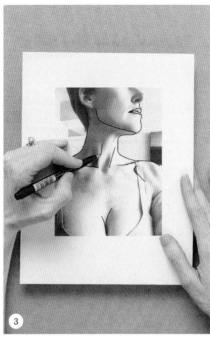

1. Take a well-lit photo or choose a photo of a person. Profile shots work well. If the lighting is coming from one side it will create obvious shadows, which will make Step 3 much easier. Have fun with this. Try different angles. These look great as a series featuring different parts of the human form.

2. Size the photo to fit the wood slice, then print the picture onto standard computer paper. For this, I am using a basswood canvas from Walnut Hollow (See page 24 for wood suggestions.)

3. Trace the main lines of the body with a fine-tipped marker (this works best) or a pen directly onto the printed photo. Be sure to trace any shadow or line you want emphasized. Keep in mind that the lines you draw on the printed photo will be the lines you burn into the wood. Less is more. These drawn lines will act as your guideline for the transfer.

4. Once the lines are all drawn on the printed paper, transfer those lines to the wood using your transfer method of choice. (See page 28 for transfer techniques.) I suggest using either a blue Chaco or graphite transfer method to transfer the drawn lines to the wood. Go slowly and be as accurate and steady as possible as you transfer the design so the burning will be easier. Brace your pinky on the wood surface to help stabilize your hand.

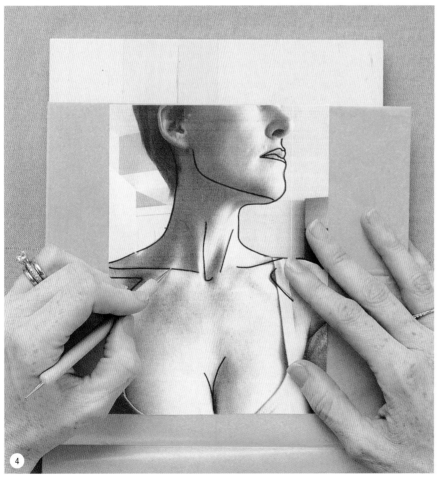

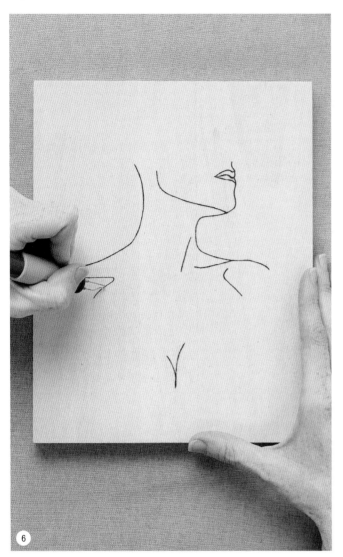

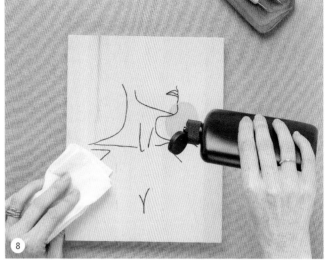

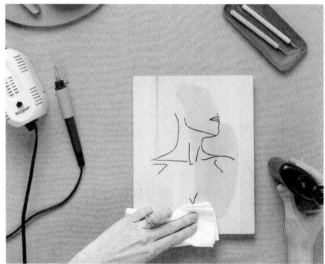

5. Make sure all lines have been transferred before removing your design. Trust me, you don't want to try to match up those lines again if you missed a spot. Pull out safety gear.

6. I recommend using a flow, spade, or writing nib for this project. (See page 18 for nib selection.) Warm up your burner and follow your transferred lines with your wood burning tool. Go slow.

7. Go back over your finished piece and remove any remaining transfer lines.

8. Don't forget to sign your masterpiece. Then top off your piece with an oil finish of your choosing. and add a picture hanger. (See page 48 for finish options.) Hang up your beautiful one-of-a-kind art piece, or wrap and gift it to a loved one.

*"Temperature, not pressure!"*

@HoneyBadgerBurnings

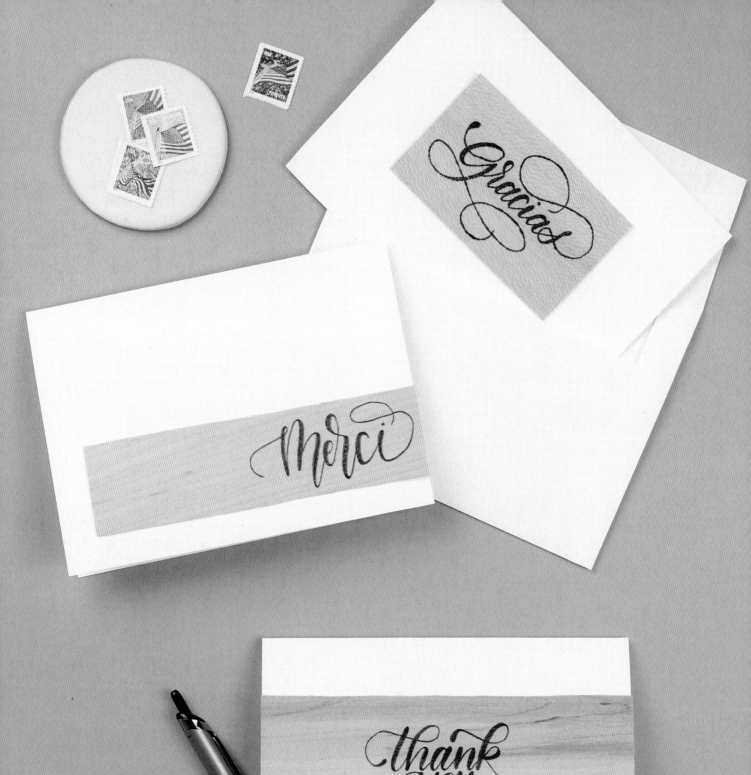

# Thank You Cards

## *Burning Wood Veneer*

**MATERIALS**

- Wood Veneer
- Designs
- Scissors, Utility Knife,
  Rotary Cutter or Paper Cutter
- Transfer Supplies
- No. 2 Pencil
- Safety Equipment
- Wood Burning Tool + Flow,
  Spade, or Writing Nib
- Blank Paper Cards and Envelopes
- Glue Adhesive or Glue Dots

Using veneer can be a great choice for wood burning. These thin flat surfaces lend themselves perfectly to handmade cards that your correspondents won't soon forget. Veneer can be cut and trimmed to different shapes and sizes and made into really unique cards.

Leslie of @leslie.writes.it.all created these gorgeous hand-lettered "thank you" designs that are the perfect way to show someone that you appreciate them. Show the love that you have with a handmade and hand burned card.

ARTIST SPOTLIGHT

**LESLIE TIEU**
of @leslie.writes.it.all
*Modern Calligrapher,
Hand-letterer, and
Watercolorist*
Pasadena, California

Leslie is a born and raised Southern California native who is self-taught in the arts of modern calligraphy, hand lettering, and watercoloring. Leslie is the artist behind the popular Instagram account @Leslie.Writes.It.All and author of the lettering workbook *Modern Calligraphy*. She is known for her colorful works and videos featuring lettering, painting, and other DIY projects. Leslie has been featured by InsiderArt and BuzzFeed for her creative and colorful videos. She has been named by CreativeMarket in their "10 Incredible Letterers" article and *Country Living Magazine* included her as one of "13 Calligraphers You Need to be Following on Instagram." She is constantly inspired by the phrase, "Creativity is contagious. Pass it on." She loves sharing her love for the lettering arts with those on social media and is excited to share her knowledge of lettering with others.

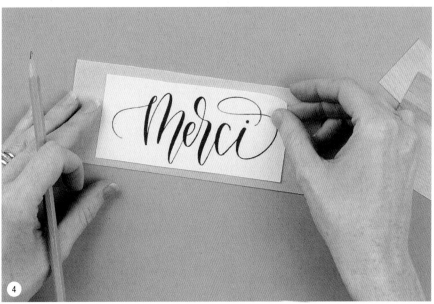

1. Choose your wood veneer and blank cards of choice. I suggest a light wood so your design will show up better. (See page 24 for wood options.)

2. Cut the wood veneer slices to fit your cards using scissors, a utility knife, rotary cutter, or paper cutter. I used my paper cutter.

3. Adjust your design to the correct size, print it, and cut it out.

4. Transfer your design to the wood veneer using Chaco paper, graphite paper, heat transfer, or pencil on paper methods. I used the pencil on paper method.

5. For this method, flip your design over and rub your pencil on the back of the paper, covering all parts with any design elements.

6. Place and tape your design on your veneer with the pencil rubbing facing the wood.

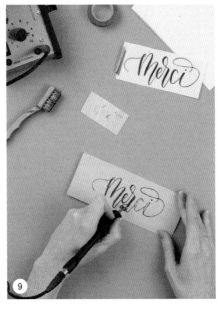

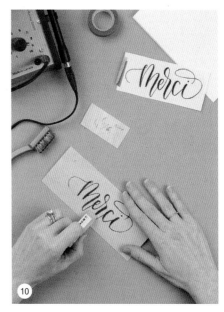

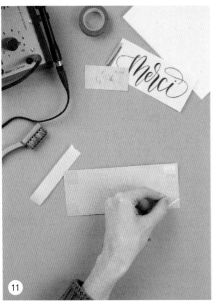

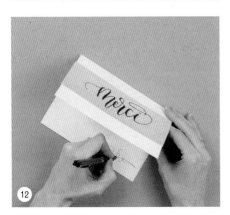

7. Follow the lines of your design with the same pencil. The better the transfer the better the final product, so go slowly and carefully here. I like to trace along the top of the lettering, go around to the underside, and then trace any holes or dots. Lift up the design to ensure all has been transferred. before removing the design.

8. Once your design has been transferred, warm up your wood burning tool with a spade, writing, or flow nib securely attached. Test your temperature on a piece of scrap veneer.

9. Follow your transferred lines with your wood burning tool. With calligraphy I recommend you start with the outside lines of the lettering and then go back and fill in the thicker parts. This will keep your lines cleaner, and you will make fewer mistakes. Also, start in the middle of the letter sequence because if you need to make adjustments, a middle letter imperfection won't be as noticeable as the first letter.

10. Remove any remaining transferred lines.

11. Attach your wood burned veneer to your blank cards using glue dots, E6000, or some other adhesive.

12. Write your note, address your envelope, and get that beautiful card in the mail!

*"Taking your time is key!"*

@woodburntflorals

Find design templates at quartoknows.com/page/ WoodBurnBook

# Leafy Trivet

## *Burning Cork*

**MATERIALS**

- Trivet
- Ceramic or Glass Bowl
- Safety Equipment
- Wood Burning Tool + Flow
  or Writing Nib

Wood burning on cork is so much fun, albeit a bit stinky. Cork is really lightweight and burns like butter. It is so smooth and just melts away under the wood burning tool, so start with a lower temperature. You will find that cork is such an enjoyable surface to burn—it is just so quick, easy, and beautiful.

Adding some wood burned touches to a plain cork trivet will liven up your table. This is a simple project that doesn't take much time but will add a lot of beauty. Bc sure to use your safety equipment when burning on cork and make sure you burn in a well-ventilated space.

*"Put a small backward facing*
*fan in front of you*
*to pull the smoke away*
*from your face."*

@baby_leaf_productions

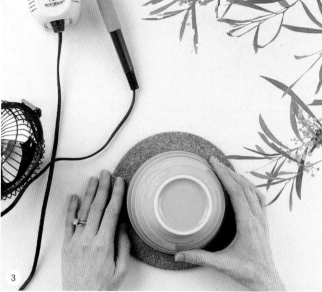

1. Ensure you have safety equipment in place. It is especially important to utilize safety equipment when working with cork. (See page 11 for safety.)

2. Choose an appropriately sized bowl for your choice of trivet. To see if it is the right size, place the bowl upside-down onto the trivet, leaving about an inch of space around the bowl to create this design.

3. The bowl will act as your stencil to get a perfectly round shape. Double check to make sure it is centered before starting.

4. Warm up your burner. When burning on cork, use a lower temperature. It burns quickly and easily.

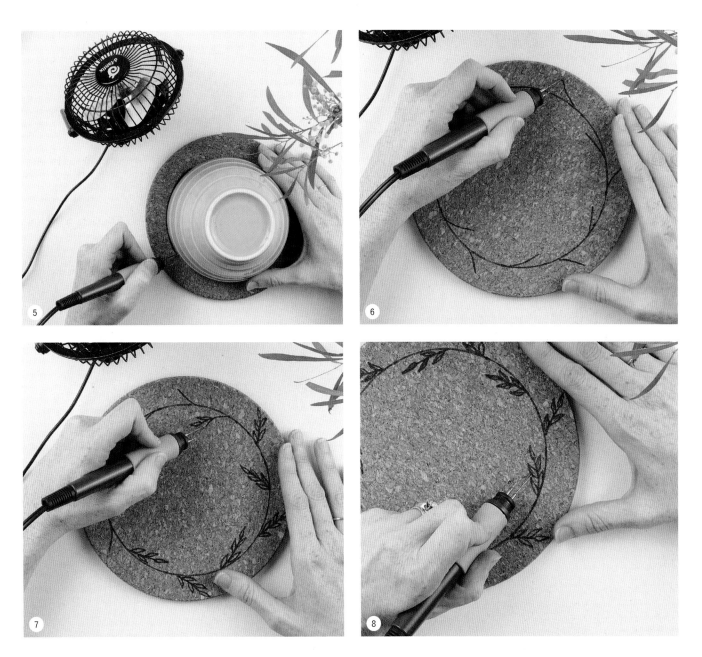

5. Holding your bowl in place upside-down, use your burner to burn right along the perimeter of the bowl, using the bowl as your guide. It's OK to touch the edge of the bowl with the burner because it is ceramic. Once burned, remove the bowl to expose the entire burned circle.

6. Add short lines off of the circle to the right and left until you have added them all the way around the circle.

7. Add the leaves. For this piece I burned a simple, tightly packed leaf pattern. Lines should have 3 to 5 leaves to achieve this look. Remember it doesn't have to be perfect.

8. Add a line vertically down the center of each leaf, and voila! You now have a new, hand burned, mostly free-handed, one-of-a-kind trivet.

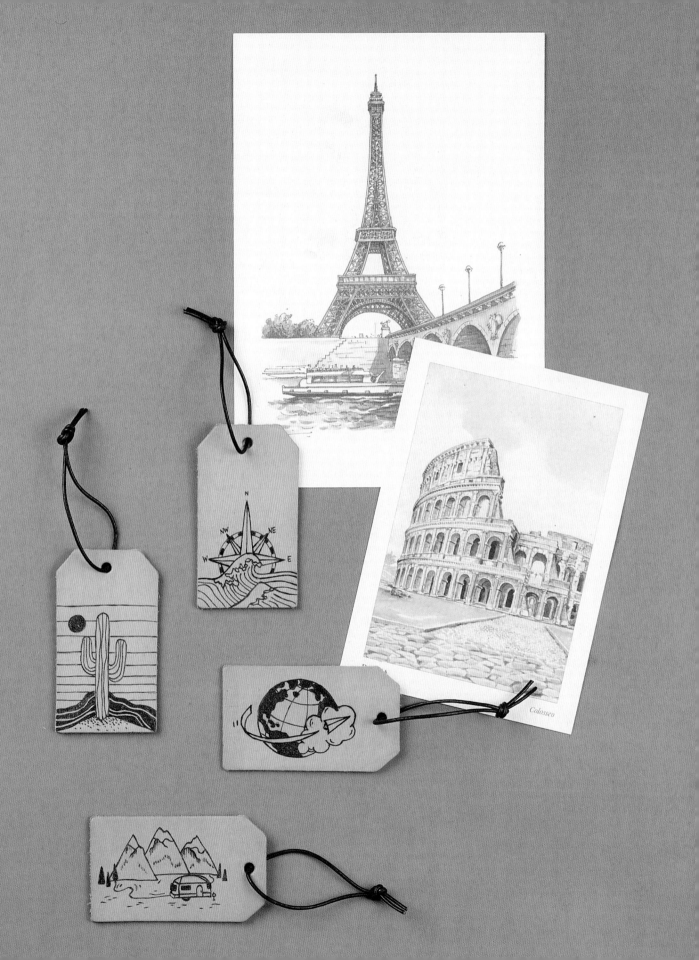

# Wanderlust Luggage Tags

*Burning Leather*

**MATERIALS**

- Vegetable Tanned Leather Tag Blank
- Design
- Transfer Supplies
- Safety Equipment
- Wood Burning Tool + Spade or Writing Nib
- Cording

These wanderlust-inspired luggage tags are made with genuine vegetable tanned leather. How cool is that! Leather is such a great surface on which to create wood burn designs, even if it is a tad stinky. Choosing the right leather is important to get a clean burn. Select leather that's thick and vegetable tanned.

Angie of @bobodesignstudio is known for her wanderlust inspired designs, and these designs are perfect for the wayward wanderer looking to create a unique luggage tag. Have fun and be sure to tag me when your tag travels somewhere new!

ARTIST SPOTLIGHT

**ANGIE CHUA**
of @bobodesignstudio
*Founder of bobo design studio*
San Jose, California

Angie is the founder, heart, and soul of Bobo Design Studio based in San Jose, California. An illustrator, lettering artist, and serial maker, Angie creates wanderlust-inspired stationery and accessories for the adventurous at heart. When Angie isn't in her studio creating, she can be found traveling the world or kicking back in her home, a 1975 vintage Airstream.

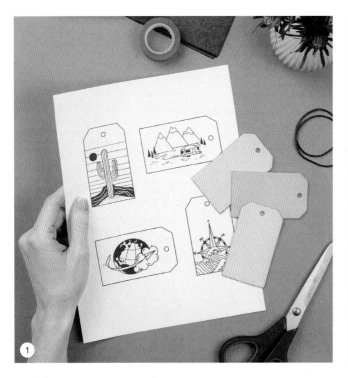

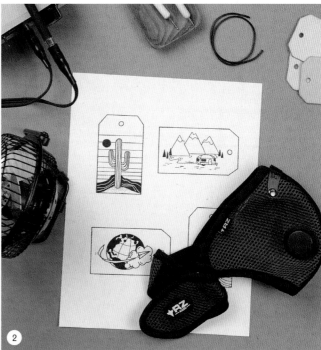

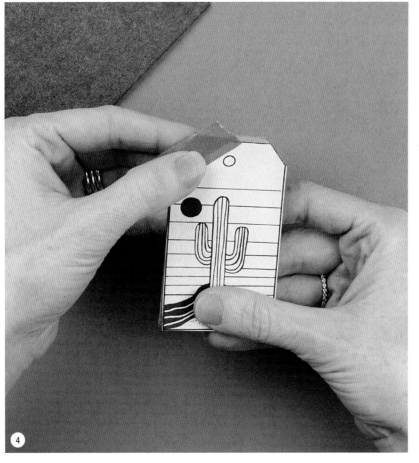

1. Choose your leather luggage tag and design. Ensure that the leather is thick and vegetable tanned. If you choose a thin leather, you could burn through it or cause it to curl up.

2. Pull out your safety gear, and put it in place. Leather can be quite smelly, so a mask, fan, and well-ventilated space are a must. (See page 11 for safety.)

3. Size, print, and cut out your chosen design.

4. Place the design on the leather and tape in place.

5. Transfer the design. I used the graphite transfer method. Simply slide graphite paper underneath the design with the black side facing the leather and transfer the design by following the lines with your embossing tool. Use a light-medium pressure. (See page 28 for transfer techniques.)

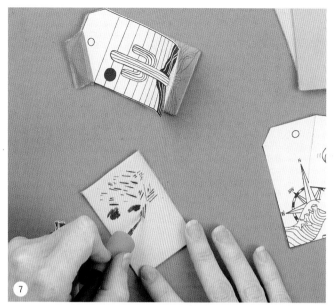

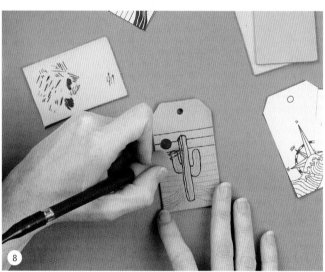

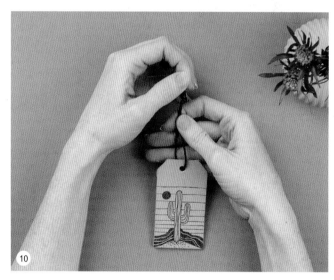

6 Remove the design and graphite paper once all of the design has been transferred to the leather.

7 Put on your safety gear. Warm up your burner and test your temperature on a scrap piece of leather. This is especially important, because leather will burn at a lower temperature than wood. When in doubt, lower your temperature and go slower.

8 Burn your transferred lines. Go slowly and carefully. Be cognizant of where you place your hand, especially since you are burning on a relatively small surface.

9 If there are any burned lines that are wider or have gone slightly off course, you can make small adjustments with a razor blade. Just carefully chip out or scrape any spots of unwanted burn.

10 Attach about 5 inches (12.5 cm) of cording with a knot at the end, and your leather luggage tag is ready to slip on to your favorite piece of luggage.

Find design templates at quartoknows.com/page/ WoodBurnBook

# Canvas Backpack

## *Burning Canvas*

**MATERIALS**

- Canvas Backpack
- Water-Soluble Fabric Pen
- Damp Sponge
- Safety Equipment
- Wood Burning Tool + Spade and Flow Nibs

Canvas is another amazing non-wood surface to embellish with pyrography. You will find canvas material in many different forms, and adding wood burned touches to any of these canvas materials will give them that personalized touch that will step up your canvas game. It is a bit smelly to burn, and you will need to clean your wood burning tool often, but it will look cool and be totally worth it. Be sure to use safety equipment. You and those around you won't want to be inhaling the fumes from burning on canvas, so be sure to work in a well-ventilated space, and have fun with it! I can't wait to see all the canvas things you whip up.

*"Always burn
in a well-lit area."*

@countrypinesshop

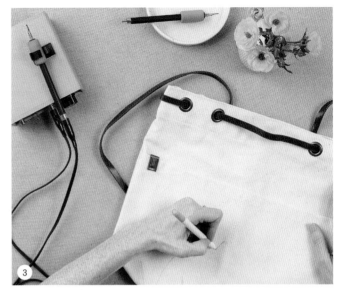

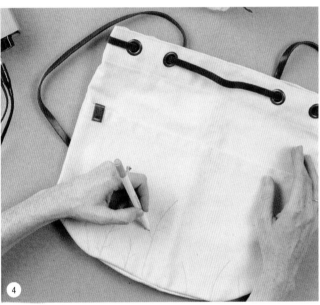

1. Wash and dry your canvas backpack.

2. Lay your backpack flat on your table.

3. With your water-soluble pen, draw lines of varying lengths and arches from the bottom of the pack going up. These can be close together or spread apart, depending on how you envision the end result.

4. Add lines of varying lengths to the right and left sides on these initial lines. Mix up the spacing between the lines to add interest.

5. Put on safety gear. Canvas can be quite smelly, and you don't want to be breathing the fumes. An outdoor environment with plenty of air flow would be best for this project. (See page 11 for safety.)

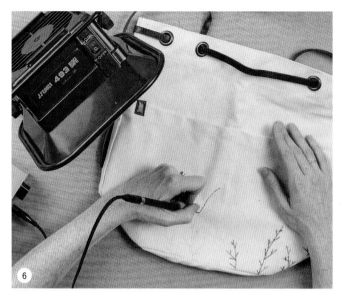

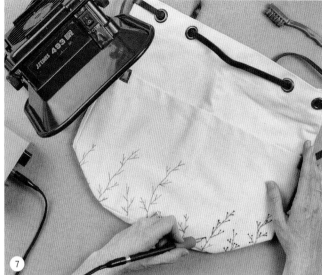

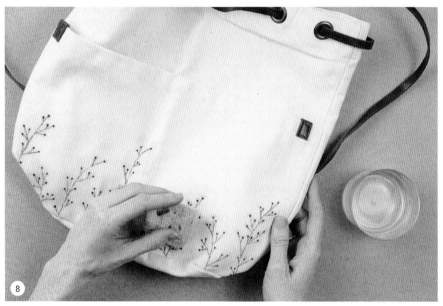

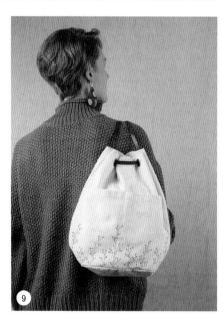

6 Turn on your wood burning tool. The temperature will depend on how quickly you would like to burn. The lower the temperature, the more controlled the burn. Start with a lower temperature and turn it up as needed. Using a spade or writing nib, burn by tracing over all of your drawn lines with the wood burning tool.

7 Once you've traced all the lines, turn off the wood burning tool and carefully switch to a flow nib, preferably a ballpoint. Reheat the burner and start adding the dots to the ends of your lines. To make a dot, simply hold the burner in place briefly. Be careful not to hold it too long, or you can burn a hole in your pack. Add burned dot ends until all lines are topped off with them.

8 Rinse off your burned backpack or use a sponge and some water to carefully remove all water-soluble pen lines. Set out to dry.

9 Wear your pack proudly and enjoy the compliments. Share online using #thewoodburnbook.

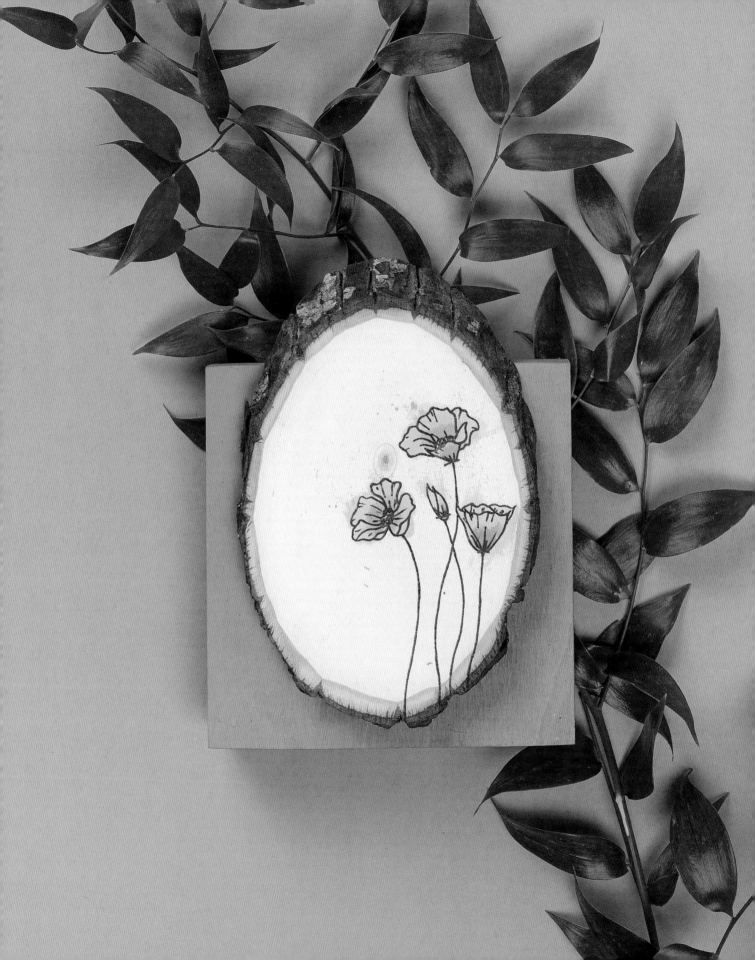

# Wood Burned Poppy Wall Art

## *Adding Loose Watercolor*

## MATERIALS

- Wood Round
- Design
- Transfer Supplies
- Safety Equipment
- Wood Burning Tool + Flow, Spade, or Writing Nib
- Watercolors
- Plate or Palette
- Water Cup
- Paper Towels
- Paintbrushes or Watercolor Water Pens
- Sawtooth Picture Hanger

Watercolor is one of my favorite mediums to add to wood. It is quite liberating to add watercolor in this unique and loose way. You can take any simple line drawing and quickly turn it into a beautiful piece of art that will add vibrancy and warmth to any space. You can create a dramatic and playful effect by adding these fun and perfectly imperfect splashes of watercolor. Those splashes of bright color change the whole look of the piece, and really bring it to life.

I chose the California poppy for this particular piece for its bright colors and because I am absolutely obsessed with them. They pop up everywhere, are super vibrant, and just make me happy.

*"Always sand your wood before burning."*

@tracedintimber

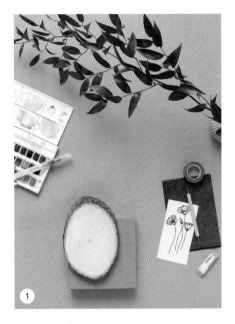

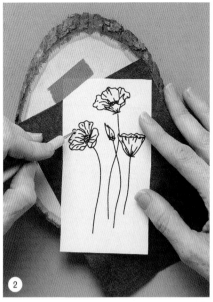

1. Choose any simple line-drawn floral design. This can be a hand-drawn doodle, a drawing from a photograph, or a design in this book. Choose a wood slice to fit the design.

2. Transfer the design to the wood. (See page 28 for transfer techniques.) I am using a slice of basswood with a live edge. Make sure you have transferred the entire design before removing the design from the wood.

3. Choose your nib and burn. For this particular piece I like to use a flow or writing nib. This gives me the freedom to burn smoothly in more directions, without catching an edge of the nib.

4. Remove any remaining transfer lines after the design has been burned in its entirety.

5. Pull out your watercolors, palette, water glass, paper towels, and paintbrushes. (See page 42 on color.)

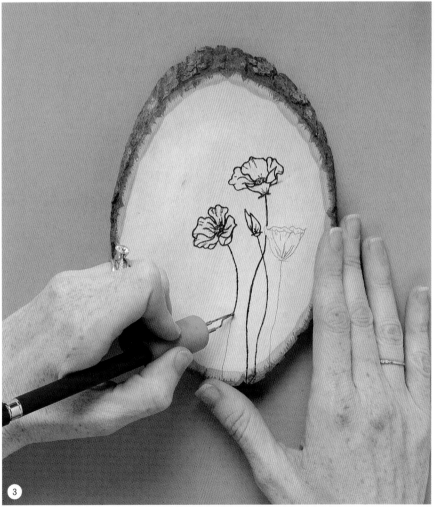

*"Don't let the 'permanence' of wood burning scare you. Sandpaper is an eraser."*

@pickleshopcuriosity

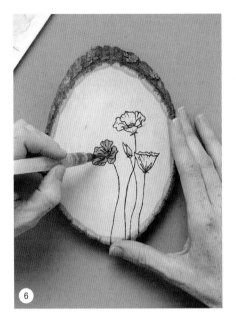

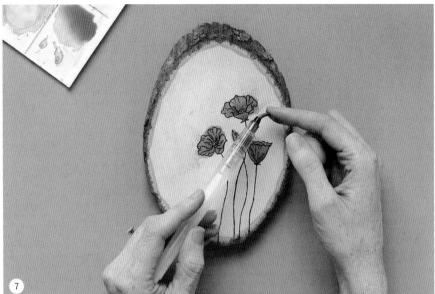

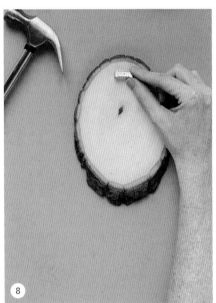

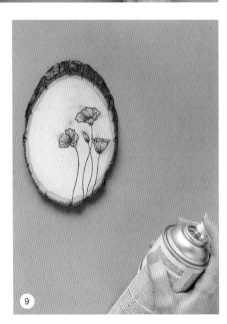

6. Color the flower fully, or at least the parts you want colored. Don't use too much water, or you might split your wood. It's OK if you go over the lines on this particular piece—you actually should! A loose watercolor look is what you are going for. This technique gives the feeling that the flower is extending past the lines it has been given.

7. Add the splashes of paint once you have completed the coloring of the flower. Practice on a scrap piece of paper or on the backside of your piece first. Dip into the same color, hold your brush close to the wood, pull back on the bristles and let them go. This will create a splashed look. You can go heavy on the splashes, or very subtle—it is entirely up to you.

8. Wait for the piece to dry, then attach a sawtooth picture hanger to the back.

9. Complete your piece with a finish of your choosing. (See page 48 for finishes.) I prefer a spray finish over watercolors, to avoid unintentionally spreading the paint on the wood.

10. Hang your design on your wall or wrap it up and give it as a gift!

Find design templates at
quartoknows.com/page/
WoodBurnBook

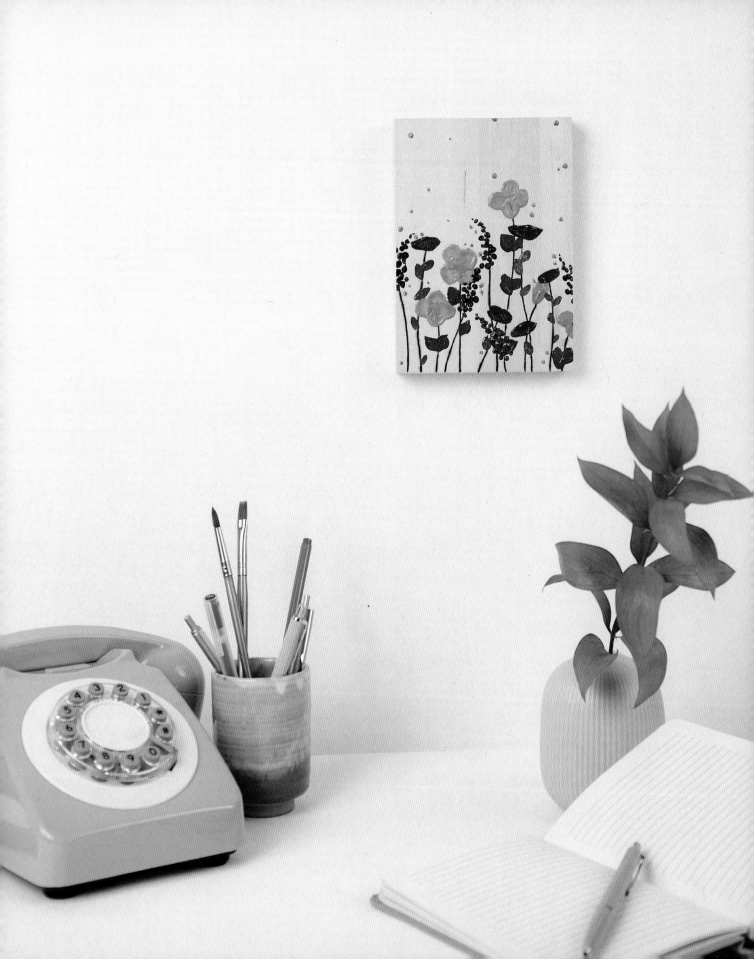

# Abstract Freehand Florals

*Adding Acrylic*

## MATERIALS

- Wood
- Sandpaper
- Safety Equipment
- Wood Burning Tool + Flow, Spade, or Writing Nib
- Pencil (optional)
- Acrylic Paint (Heavy Bodied)
- Paintbrush
- Water Cup
- Palette
- Paper Towels
- Finish

Acrylic Paint is such a great color medium to add to wood burned pieces. Like wood burning, acrylic paint adds texture and depth to a piece of wood, but by building up instead of carving away. This adds interest, vibrancy, texture, and warmth to a wood burned piece. Acrylic paint can also be watered down to create a wash; both will be applied in the making of this piece.

This project can be created using your favorite colors or with specific flowers you might have in mind, and varying levels and types of texture. Add more flowers of different hues or think about creating fewer flowers of only one type. This quick and simple free-hand design allows you to customize it to fit your needs. I can't wait to see what you all do with this simple, quick, and fun project.

*"Whether it's paint,
colored pencil, watercolor
or a finish you are adding,
always burn first."*

@alyoopsartistry

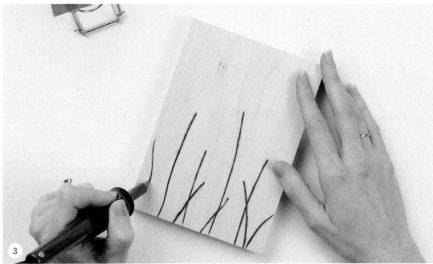

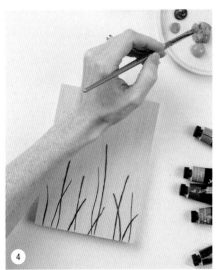

1. Pull out all your safety gear, and make sure the wood is dried and sanded smooth. (See page 24 for wood recommendations.)

2. Warm up your burner and test your temperature.

3. Burn several stems or lines into the wood of varying lengths across the bottom of your wood piece. Have some of them cross each other and bend in different directions. If you are nervous about putting the burner straight to wood, you can quickly draw the lines with pencil before burning.

4. Pull out your acrylic paints, a paintbrush, a water cup, palette or paper plate, and paper towels. Choose colors that work with your home, or flowers that you would like to emulate. Squeeze a generous amount of each color onto your palette. Think about blending more than one color together for each flower color to give your flowers more depth. Don't forget about greens. Use a couple different green hues for your leaves to add variety.

5. Once you are happy with your palette, scoop up a large amount of paint on your paintbrush and add it to your piece. Don't be afraid to use a lot of paint. I have found that the more paint I use, the better the result. This will give your piece a lot of texture and make the flowers three-dimensional. They don't have to be perfect. You just want the paint to give the idea, feeling, or suggestion that they are flowers. Use one color at a time and add the flowers or leaves of that color until you feel it is balanced. Then clean the brush and move on to the next color. If you would like to build up your layers, allow your paint to dry completely, this can take a couple hours, between colors. The time will be worth it. (See page 43 on color.)

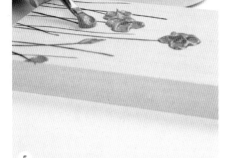

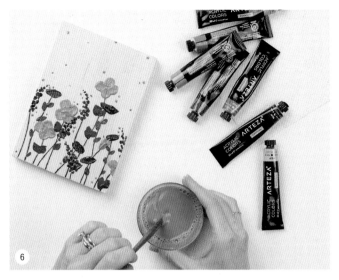

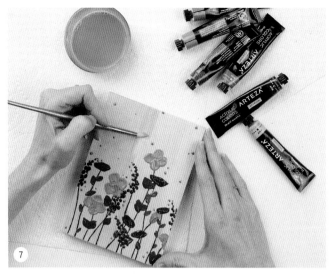

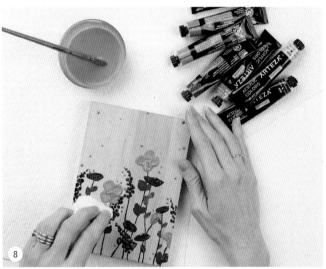

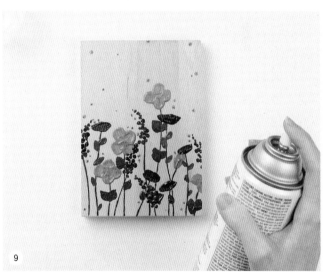

6. Create an acrylic wash. First, choose your acrylic color(s) and mix a small amount with a copious amount of water. Start at a 1:10 ratio and adjust as needed. This color can be sky blue, like I have here, or you can create a sunrise or sunset effect by using multiple colors, or anything your heart desires. This is your mixed media piece of art—feel free to really make it your own!

7. Allow your paint to dry completely and test your wash on scrap wood before applying it to your finished piece with a clean brush. Testing your color will help you avoid adding too much water, which may split or warp your wood. Do not add more than two coats of wash for this reason. Do not worry about getting it on the flowers—just brush it evenly on the whole piece.

8. Quickly use a clean paper towels to soak up any liquid on the flowers before it dries. The wash will stick to the wood but will come right off of the dried flowers and burned lines while it is still wet.

9. Allow your piece to dry completely, then apply a finish. I prefer a spray finish when working with thick/heavy-bodied acrylics like this, so that it doesn't pool in the grooves of the paint. (See page 48 for finishes.)

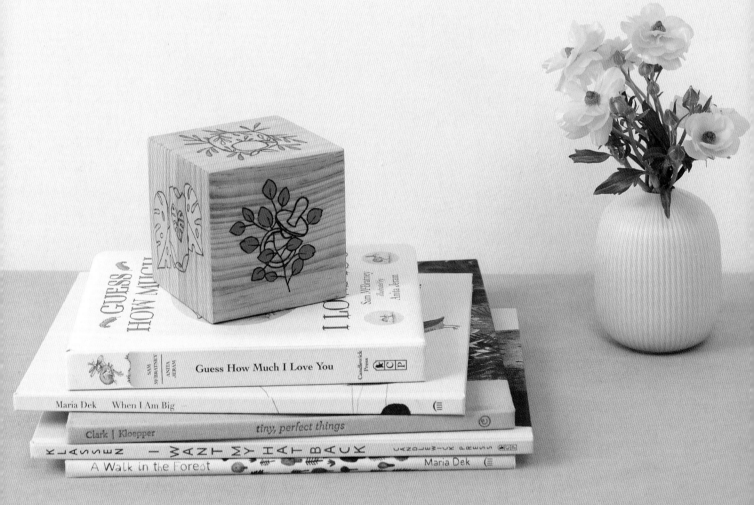

GUESS HOW MUCH

I LOVE YOU

Sam McBratney
illustrated by
Anita Jeram

Guess How Much I Love You    Candlewick Press    C|P

Maria Dek    When I Am Big

Clark | Kloepper    tiny, perfect things

KLASSEN    I WANT MY HAT BACK

A Walk in the Forest    Maria Dek

# Baby Block

## *Adding Paint Pen*

## MATERIALS

- Wooden Block
- Design
- Transfer Supplies
- Safety Equipment
- Wood Burning Tool + Flow, Spade, or Writing Nib
- Paint Pens

These fun and whimsical botanical baby designs lend themselves so perfectly to the addition of paint pens. Adding color using paint pens infuses a piece with a liveliness and cheerfulness. Paint pens are so vibrant and color rich, they really help highlight these adorable designs from the amazing Eunice of @electriceunice.

I have put these designs on a wooden block, but they could be added to so many different wooden surfaces. I can't wait to see how you use Eunice's beautiful designs to create wood burned keepsakes for the little ones in your life.

ARTIST SPOTLIGHT

### EUNICE SUN

of @electriceunice

*Watercolor Artist & Designer*

Irvine, California

Eunice Sun is the watercolor and lettering artist behind Electric Eunice and author of her watercolor instructional book, *Watercolor Botanicals*. Eunice loves to create to encourage relaxation, positivity, and laugh-out-loud moments. Beyond designing, she cultivates most of her energy and joy from being around others. With her passion for igniting the creative fire within, she teaches watercolor workshops with a love language that says, "No matter what your background is, you can do this!" She is known for her loud laugh, love for painting plants, and being every girl's BFF. She is based in Orange County, California, with her husband, their corgi mix, and their newest addition—a little human baby.

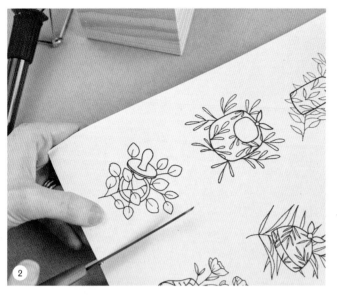

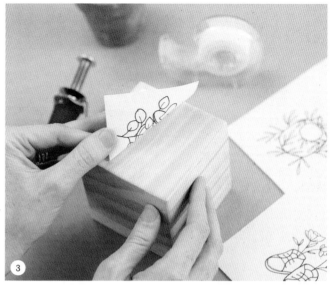

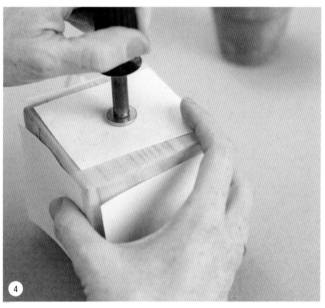

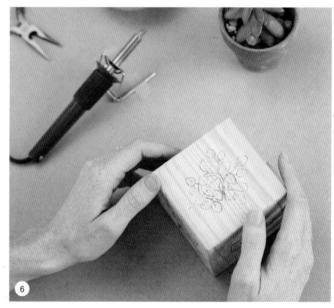

1. Size the designs to fit the wooden block.

2. Choose a transfer technique. A graphite, heat, or Chaco paper transfer would work well for this. I will be using the heat transfer method, so I have printed my designs in reverse using a laser printer. Take care to reverse the image before printing, especially if you add text, and cut out the designs.

3. Place and tape the designs to the wood. I will be placing them with the ink facing the wood for this transfer technique. Pull out your safety gear.

4. Transfer the design by making circles using the hot wood burning tool with the transfer nib while applying hard and even pressure. Do not stay in one place for too long, or you will scorch the wood.

5. Ensure all has been transferred before removing the designs.

6. Choose your nib. A flow, spade, or writing nib works well for this project. (See page 18 for nib options.)

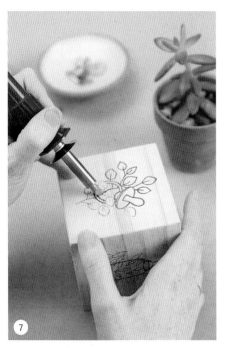
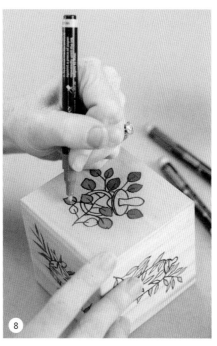

7. Heat up your burner, test the temperature on scrap wood, and then carefully wood burn the transferred designs. If you are finding it hard to burn on this three-dimensional surface, try placing another block or something similar in size next to the piece you are working on where you can rest your hand. Also, use your pinky finger to steady your hand on the block and let the burner do the work.

8. Once you have burned all the sides of the block, pull out your paint pens and add touches of color to the designs. This will really brighten up these adorable designs. Think about adding colors that match a room, or use a variety of colors. Have fun playing with color. When turning the block to work on different sides, be sure the side that is touching the table is dry before setting it down. You don't want to smear the paint. (See page 43 on color.)

9. Once dry, apply a finish to keep your block looking beautiful. If the baby will come into contact with the block, be sure to use a finish that is food safe. (See page 48 for finishes.)

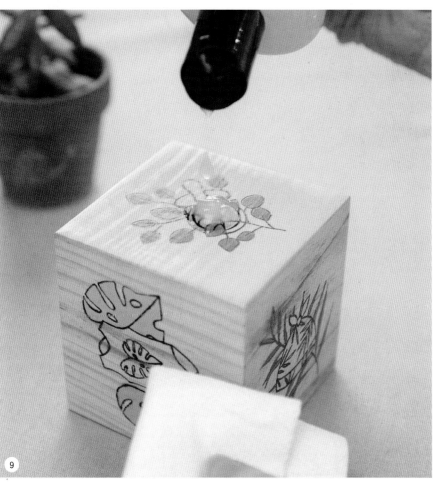

Find design templates at
quartoknows.com/page/
WoodBurnBook

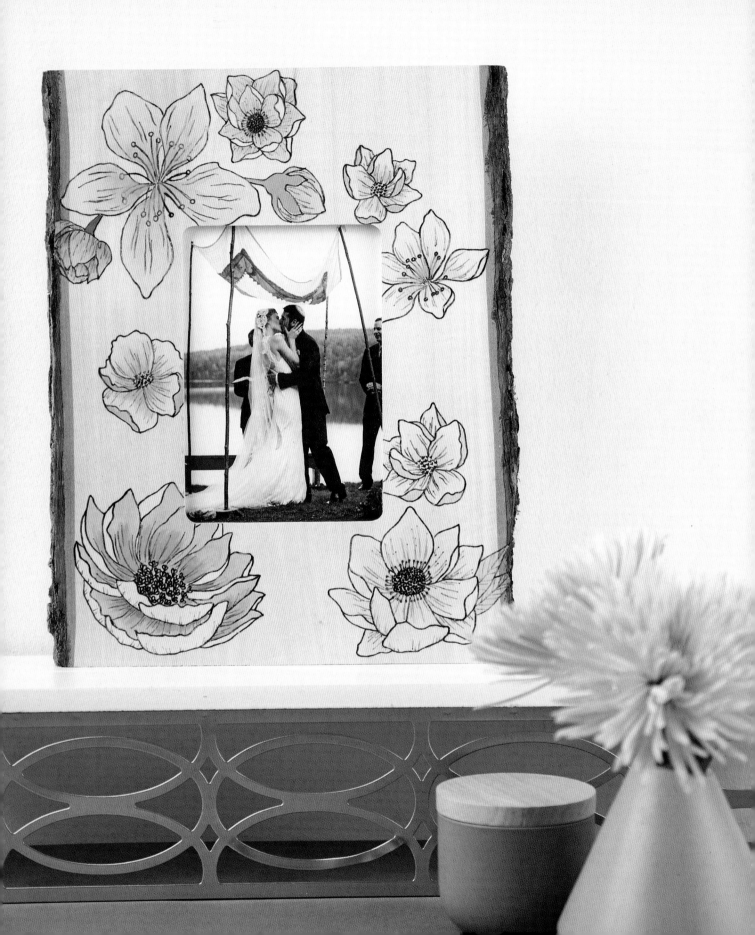

# Floral Picture Frame

## *Adding Gouache*

**MATERIALS**

- Wooden Picture Frame
- Designs
- Transfer Supplies
- Safety Equipment
- Wood Burning Tool + Flow,
  Spade, or Writing Nib
- Gouache Paint
- Palette
- Paintbrush
- Water Cup
- Paper Towels
- Finish

Gouache is such a fabulous way to add color to a piece. You can water it down to give a more subtle appearance or build it up to add texture and depth. These beautiful florals by Jessica of @brownpaperbunny lend themselves so perfectly to the use of gouache.

A design that is pieced together like this means that no two picture frames will be the same. You will be placing the individual flowers onto the wood piece to create the overall look or design. It is completely unique, and you can customize these florals to fit your needs in size, location, and color. It makes me giddy to think about all the different combinations that are possible with these beautiful designs from Jessica and your unique eye.

ARTIST SPOTLIGHT

**JESSICA MACK**
of **@brownpaperbunny**
*Artist and Illustrator*
Seattle, Washington

Jessica is an artist and illustrator with a particular love of florals and fashion illustration. Her work has a fun, fresh, and vibrant feeling to it, and she works mainly in watercolor and ink. Jessica is also passionate about helping people find and nurture their own creativity and enjoys teaching others. Originally from Australia, she's lived all around the world but has settled (for now) in Seattle, Washington.

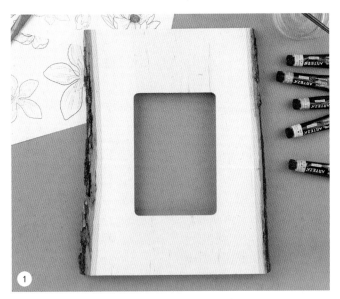

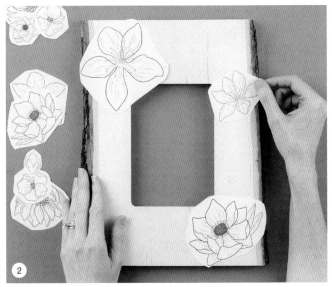

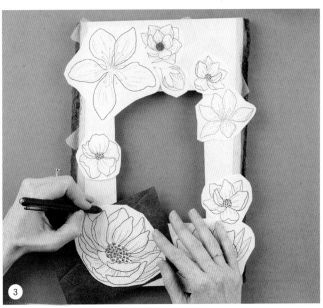

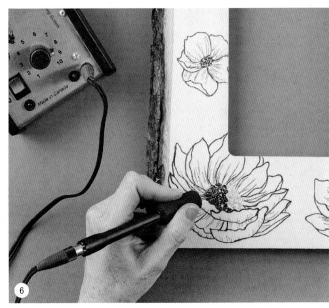

1. Print the designs and adjust the sizes to fit the picture frame. I am using a basswood picture frame with a live edge from Walnut Hollow.

2. Cut out the individual flowers and begin placing them around the frame. Once they are placed and sized, secure them in place depending on your transfer method of choice.

3. Transfer the designs to the wood. (See page 28 for transfer techniques.) For this particular piece, I will be using the graphite transfer method.

4. Once designs have been transferred, remove the graphite paper and designs.

5. Secure the nib of choice into your wood burning tool. (See page 18 for nib options.) For this piece I suggest a flow, spade, or writing nib.

6. Warm up your burner, test your temperature, then carefully follow all of your transferred lines. Go slow and let the wood burner do the work for you. Let it glide. Switch out and use a couple different nibs to add texture.

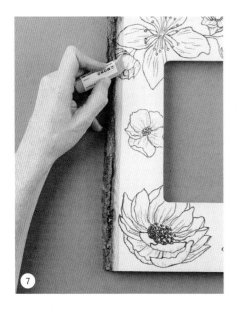
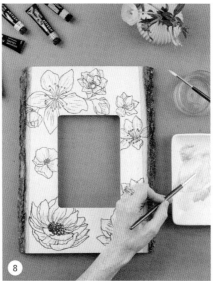
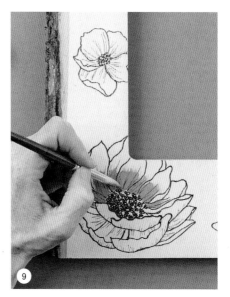

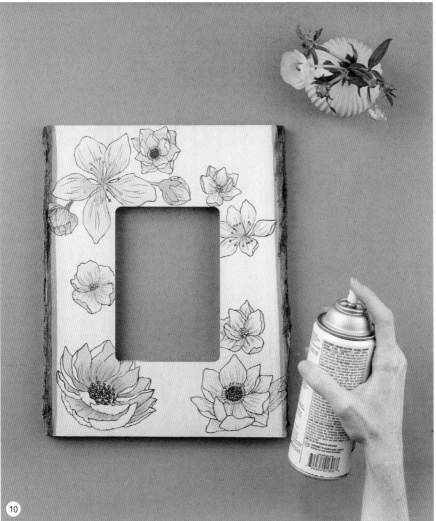

7  Remove any remaining transferred lines.

8  Pull out gouache paints, palette, paintbrush, water, and paper towels.

9  Apply gouache paint to wood. Be careful not to use too much water, because it can split the wood.

10  Ensure the gouache has dried completely, then apply the finish. For this piece I will use Workable Fixatif spray finish. (See page 48 for finishes.)

Find design templates at
quartoknows.com/page/
WoodBurnBook

# Kawaii Magnets

*Adding Gel Pen*

**MATERIALS**

- Tiny Wood Slices
- Transfer Supplies
- Tape
- Larger piece of wood
- Safety Equipment
- Wood Burning Tool + Flow, Spade, or Writing Nib
- Magnets
- E6000 Glue
- Cotton Swabs
- Gel Pens
- Finish

Gel pens are great for using on wood burned projects because they are easily accessible, not messy, come in so many colors (including metallics and neons), and are easy to apply to small areas. These fun little gel pen magnets are just so perfect for the adorable designs by Jess from @jeshypark.

These magnets are both useful and whimsical, and who doesn't love that?! They are super simple to make but will surely add character to any refrigerator. I can't wait to see how you take these designs and add your own twist! Be sure to share your finished pieces using #thewoodburnbook.

ARTIST SPOTLIGHT

**JESS PARK**
of @jeshypark
*Watercolorist, Calligrapher,*
*Illustrator, Author*
Napa, California

Jess Park is a watercolorist, calligrapher, illustrator, and author of the book *Watercolor Lettering: A Step-by-Step Workbook for Painting Embellished Scripts and Beautiful Art.* Jess loves to teach and encourage aspiring artists through her lettering guides, online and face-to-face workshops, and large social media presence. Jess' message has always been to have fun while creating, and she spreads this positive message through her playful and colorful artwork that can be found on Instagram.

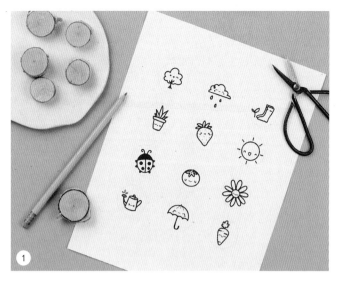

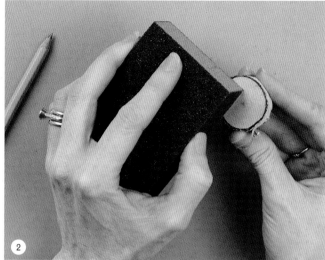

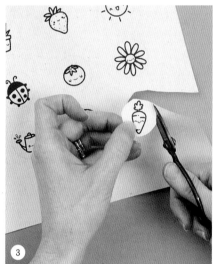

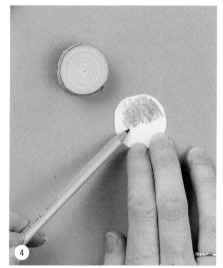

1. Choose your designs, size them, print them.

2. Sand your tiny wood slices smooth. I am using mini birch slices. (see page 24 for wood options.)

3. Cut and place the designs on the wood slices.

4. Choose a transfer method. (See page 28 for transfer techniques.) I suggest a graphite, blue Chaco, or pencil on paper methods. I am using the pencil on paper method.

5. Tape your tiny wood pieces to a larger wood slice from the backside. Taping them down will hold them in place and allow you to easily turn them while you transfer and burn without worrying about getting burned. I learned this trick from @northstar_pyrogrpahy.

6. Transfer the design. Remember, the more accurate the transfer, the cleaner the burn will be.

7. Warm up your burner with your nib of choice securely attached.

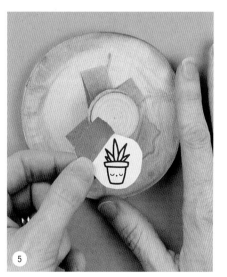

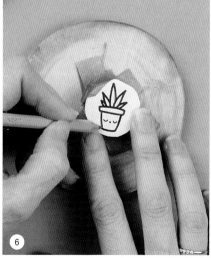

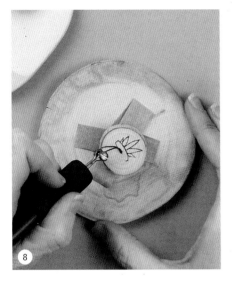

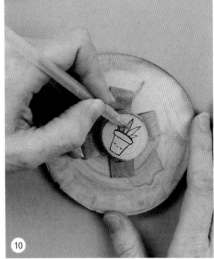

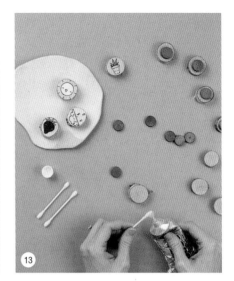

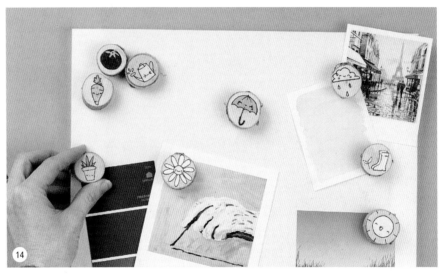

Test your temperature on the back of one of your wood slices before getting started.

8 Follow your transfer lines. Go slowly and be careful. Keep your fingers out of the way. Consider using a different wood slice or object of equal thickness as a working surface on which to rest your hand. This will allow you to burn more carefully and precisely with a steadier hand, which is especially important when working on something small.

9 Remove any remaining transfer markings.

10 Embellish your tiny wood burned designs with gel pens. There is no wrong way to do it, and I encourage you to go for it! Use metallic, neon, or monochrome colors. Color the whole thing, or just add accents. It is completely up to you! (See page 42 on color.)

11 Once you are happy with the look, add a spray finish to keep them looking great for a long time. Allow to fully dry.

12 Pull out magnets, E6000 glue, and cotton swabs. Flip the tiny burned slices over so the backside is facing up.

13 Get a good amount of E6000 glue on the cotton swab and rub it on one side of a magnet. Quickly place and slightly squish the magnet onto the backside of the wood burned piece. Check on them after a few minutes to re-center any of the magnets which may have shifted position. Allow the glue to dry overnight.

Be sure to work in a well-ventilated space because the glue can be quite stinky, and follow the guidelines listed by the glue manufacturer.

14 Once dry, your adorable handmade magnets are ready for use!

Find design templates at quartoknows.com/page/ WoodBurnBook

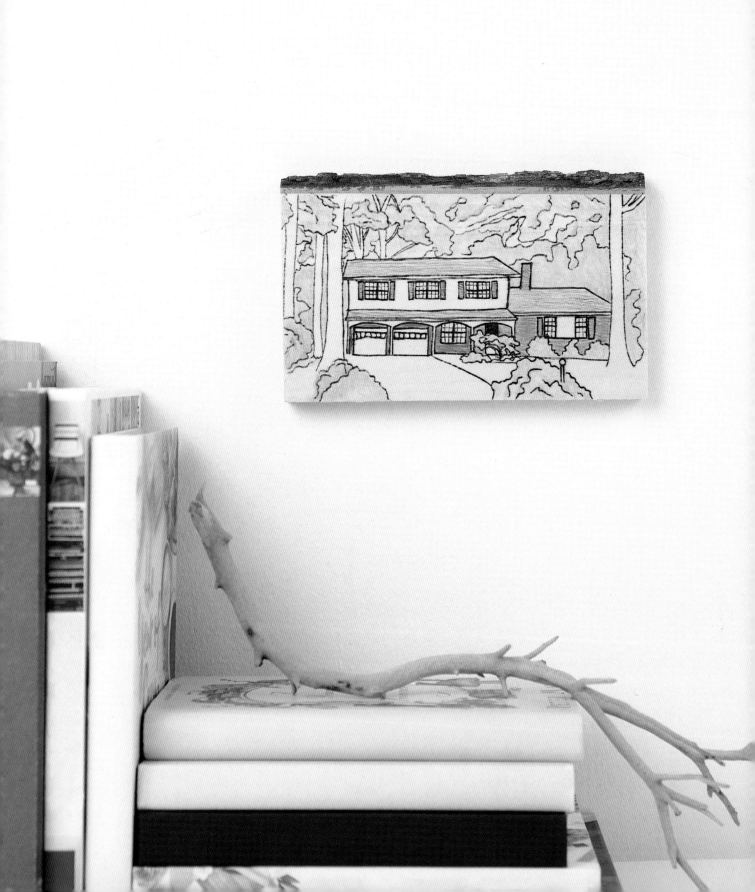

# Home Sweet Home Sign

## *Adding Colored Pencil*

**MATERIALS**

- Wood Canvas
- Digital Photo
- Transfer Supplies
- Pen (optional)
- Safety Equipment
- Wood Burning Tool + Flow, Spade, Writing, and/or Shading Nib
- Colored Pencils
- Finish

Colored pencils are such a fabulous choice for adding precise color to to a wood burned piece. I love adding colored pencils to projects like this home, where those pops of understated color add interest to the piece. This customizable project is simple and only requires tracing skills.

A handmade, one-of-a-kind piece can be made using a black and white photo printed on regular printer paper. It's inexpensive, fun to make, completely customizable, and always a well-received gift because of its sentimental value. Just always double check the address!

*"Turn your wood
as you burn."*

@west.pyrography

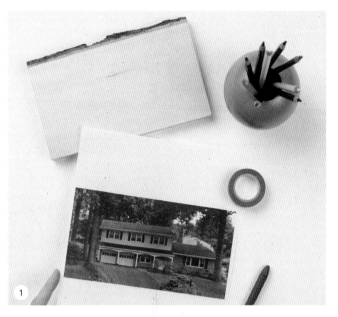

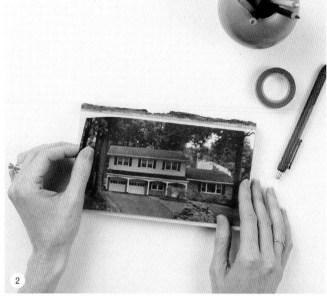

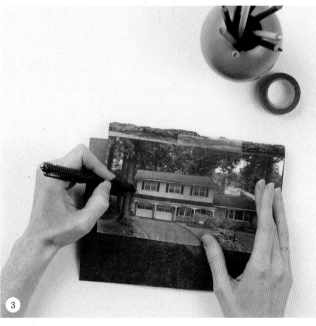

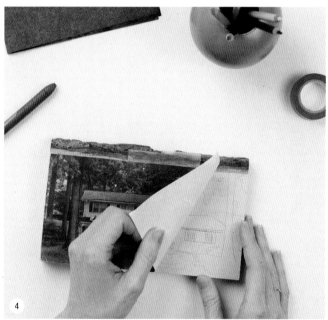

1. Take or choose a well-lit photo of the home of your choosing.

2. Size the photo and print it in black and white to fit on your wood slice of choice. For this I will be using a slice of basswood with live edge on one side. (See page 24 for wood choices.)

3. Using either the Chaco or graphite method, transfer all the major lines and details of the home to the slice of wood. Go as detailed or minimalist as you'd like. I used the graphite transfer method. (See page 28 for transfer techniques.) If you are unsure what parts you want to transfer, I suggest drawing the lines that you want to transfer first in red pen on the image. Then, when you transfer, you can follow those red lines.

4. Ensure you have transferred all of the design before removing the photograph.

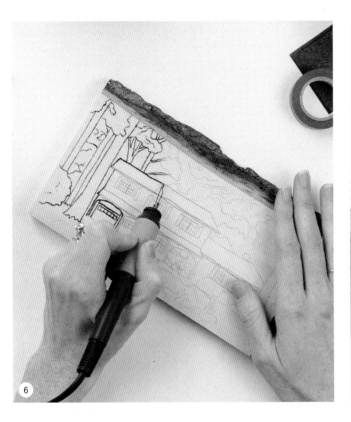

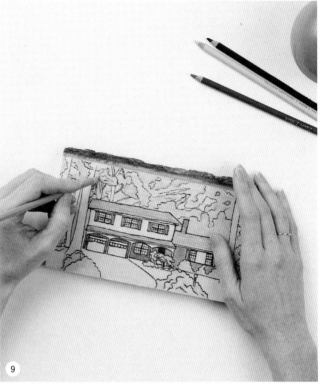

5. Choose the nib of your choice and heat up your wood burning tool. Be sure to follow all safety guidelines. For this project, almost any nib will do. Flow, spade, shading, or writing nibs will all work. It may depend on the part of the house that you are wood burning. If you want fine lines, choose a spade style nib. If you want to make a bush, try a flow nib. Maybe try a shading nib to add more detailed elements.

6. Carefully burn all of your transferred lines. Go slowly and steadily. Use your pinky to support and steady your hand. Let the wood burner do the work for you. Glide.

7. Once wood burning is complete, remove any remaining transfer lines.

8. Add colored pencil to the areas you would like to accentuate.

9. Color as much or as little of the piece as you'd like. Go bright, or add white, blend your colors, or go with a more muted look. Play with it. (See page 42 on color.)

10. Finish your piece with a finish of your choosing. For this I chose a spray polyurethane. (See page 48 for finishes.)

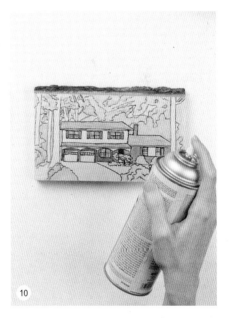

# Art Deco Wooden Box

## *Adding Wood Stain*

**MATERIALS**

- Wooden Box
- Design
- Transfer Supplies
- Safety Equipment
- Wood Burning Tool + Flow,
  Spade, or Writing Nib
- Water-based Wood Conditioner
- Water-based Wood Stain
- Paintbrush
- Finish

Wood stain is a great way to add color to a piece and has been used for centuries to change wood's color without losing the grain. Stain can be added to small portions with a small paintbrush (like I have done here), to larger parts, or even to the entire piece. There are so many stain color options available beyond the usual browns, and they can be used in ways that really accentuate and elevate a design.

For this geometric, Art Deco style piece, I wanted to just emphasize parts of the design by using stain. Once you know that wood stains are an option, it becomes quite fun to think about the different ways that you could stain particular pieces.

*"Whenever I've made a mistake that I need to erase, I use sandpaper, a sand eraser, or a razorblade."*

@alyoopsartistry

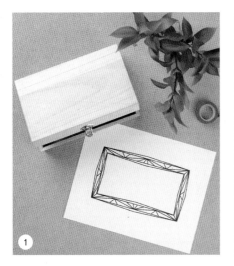

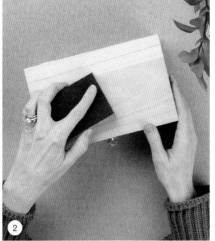

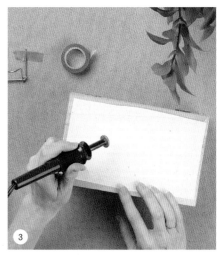

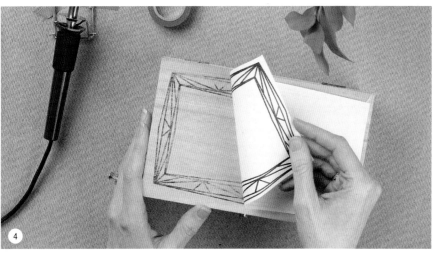

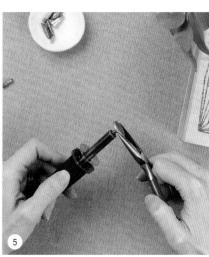

1. Size your design to fit the box. Choose your transfer method. I will be using the heat transfer method. I start by printing the design using a laser printer. Because the design I am using has a lot of straight lines, using the heat transfer method will make my burned lines much cleaner. (See page 28 for transfer techniques.)

2. Sand your unfinished wooden box smooth.

3. For a heat transfer method, next you will warm up your solid-nibbed burner with the transfer nib securely attached. Place the laser printed design face down on your wooden box, and tape in place. Make sure your tape is not on or near your lines that you will be transferring, or you may end up burning your tape.

4. Transfer the design by moving the burner in small circles on the backside of the design with hard, even pressure. Peek and make sure all lines are transferred before removing your design.

5. Once design is fully transferred, remove your design and turn off your wood burning tool. Wait for the burner to cool and carefully remove your transfer nib with a pair of needle nose pliers and place it in a ceramic dish to cool. Replace the nib with your spade or writing style nib, secure it to your burner with your pliers, and turn the burner back on.

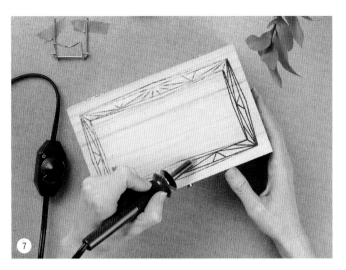

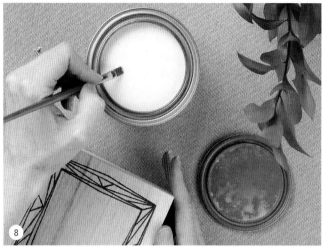

6  Allow burner to heat up and test your temperature on a scrap piece of wood or on the underside of your box.

7  Follow your transferred lines with your wood burning tool. Go slow and steady. I like to do the outlines of my lines first and then fill in later. This allows me to carefully pull my burner down the line, and rotate the box as needed to keep pulling towards me until I get all the lines without having to stop to fill in. I also will use another box, or stack of wood so that my burning hand is at the height of the box I am burning. My pinky finger resting on a stack at the same height allows me to be more accurate with my fine motor movements.

8  Once burning is complete, add a water-based wood conditioner to your wood where you will be adding stain and let it dry. The conditioner allows your stain to be applied more evenly. Be sure to use a water-based conditioner for a water-based stain, and an oil-based conditioner for an oil-based stain. (See page 42 on color.)

9  Using a paintbrush, apply stain to the pre-conditioned parts of the wood. Don't add too much liquid, because it can spread and seep into parts of the wood that you are not intending to stain. Add little by little to avoid this and allow to dry before adding another coat. If you are doing large areas or an entire piece, be careful not to use a stain that is too dark, or you will lose all the wood burned details you worked so hard on.

10  Apply a finish to your wooden box. Think of what you plan to do with the inside of your box when choosing a finish. For example, if you plan to line it with paper or cloth, you may want to steer clear of oil finishes that might bleed onto the paper or stain the cloth. (See page 48 for finishes.)

Find design templates at quartoknows.com/page/ WoodBurnBook

# Kid's Art Keepsake

*Adding Marker*

## MATERIALS

- Wood
- Original Art Design
- Transfer Supplies
- Wood Burning Tool + Flow, Spade, Writing, or Shading Nib
- Markers
- Finish
- Sawtooth Picture Hanger

---

ARTIST SPOTLIGHT

**ABIGAIL** (age 7)
**EVELYN** (age 5)
**ISAAC** (age 3)

*Self-portraits of Rachel's three beautiful children*

---

Markers can add a vibrancy to a piece of wood burned art. They are easy to apply, clean, and come in a variety of colors. This kid's art keepsake is a wood burned collaboration (of sorts), because the child is actually the artist. This technique or method is really fun to do with little ones. Children love watching their art come to life in this unique and long-lasting way.

Any design, handwriting, or drawing can be preserved with this technique, or you can create a fun experience and have the child draw directly onto the piece of wood. After you have hand burned the artist's work, you can add the colorful marker touches yourself, or hand it back to the child to complete themselves. Either way, the finished masterpiece will be one of those treasured pieces of art that the whole family cherishes.

1. Choose a beautiful already made design or have a child draw one.

2. Size and fit it to a piece of wood of your choosing. (See page 24 for wood suggestions).

3. Once you have placed the design, tape it down, and transfer it to the wood using either the Chaco paper or graphite transfer method. These methods will preserve the original drawing. Be sure to use an embossing tool, because a pencil or ballpoint pen would ruin the original drawing. (See page 28 for transfer techniques.)

4. Once all of the art has been transferred, remove the design. Choose a wood burning nib, secure it to your wood burner, and heat up the tool. (See page 18 for nib selection.)

5. Follow all transferred or drawn lines with your wood burning tool. Go slow. Pull, don't push and use gentle, even pressure. Let the child artist safely observe this part, if possible. Kids love watching it!

6. Remove any remaining transferred or drawn lines.

7. Pull out the markers and add those final touches. These marker touches can be added to re-create the original piece of art, to accentuate part of the piece, or can even be handed back to the child artist to finish off themselves. The children will feel such a sense of pride to be involved in the project. (See page 42 on color.)

8. Add a finish to your piece, and a sawtooth picture hanger so the masterpiece can be hung and enjoyed by all for years to come. (See page 48 for finishes.)

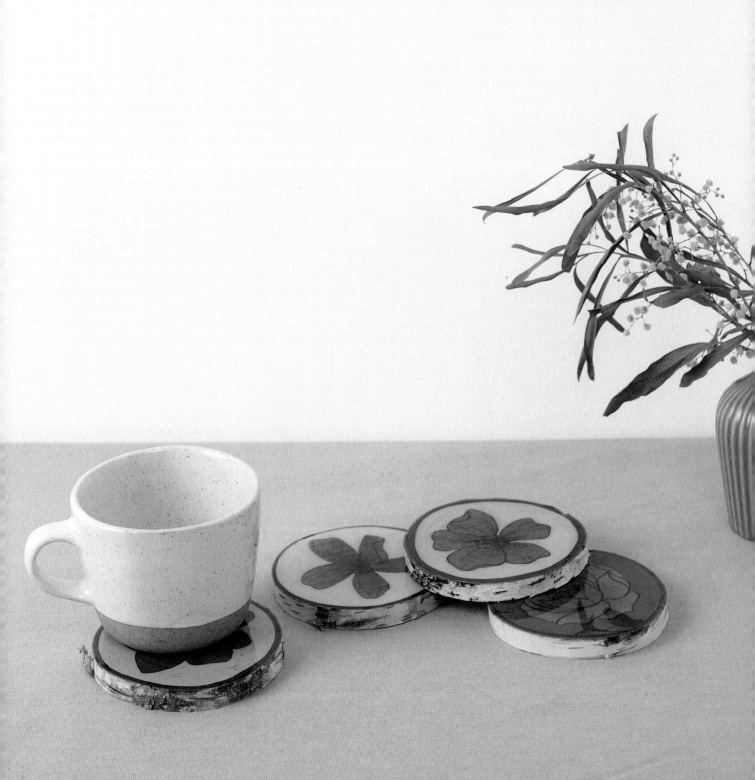

# Line Drawn Floral Coasters

*Adding Chalk Marker*

## MATERIALS

- Wooden Coasters
- Design
- Transfer Supplies
- Safety Equipment
- Wood Burning Tool + Flow,
  Spade, Writing, or Shading Nib
- Chalk Markers
- Water-Resistant Finish

Using chalk marker to embellish a wood burned project adds a matte color that I think is just so dreamy. Chalk paints come in a variety of colors, and chalk markers make applying chalk paint easy and fun.

These beautiful line-drawn florals from Peggy of @thepigeonletters look so cute together as a coaster set and would make for a fantastic gift. I finished these chalk marker coasters with a resin finish to protect them and keep them looking beautiful for a long time. I can't wait to see how you use Peggy's pretty designs and incorporate chalk paints in your wood burned pieces.

ARTIST SPOTLIGHT

**PEGGY DEAN**
from **@thepigeonletters**
*Author,*
*Artist & Educator*
Portland, Oregon

Peggy Dean is a nationally recognized freelance artist, a best-selling author (*Botanical Line Drawing, Peggy Dean's Guide to Nature Drawing & Watercolor,* and *The Ultimate Brush Lettering Guide,* to name a few. . . ) and an award winning educator. She is the founder of The Pigeon Letters—a platform to inspire and provide resources to anyone with a passion to create. She lives and works in Portland, Oregon and travels the world for speaking engagements and hands-on workshops.

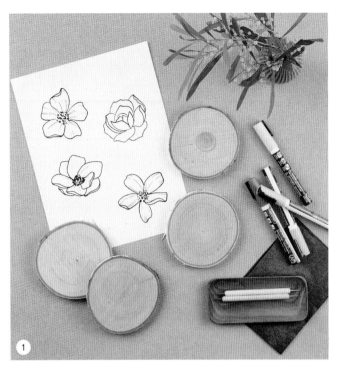

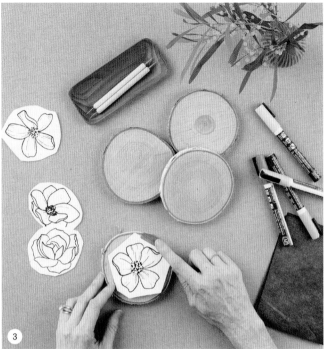

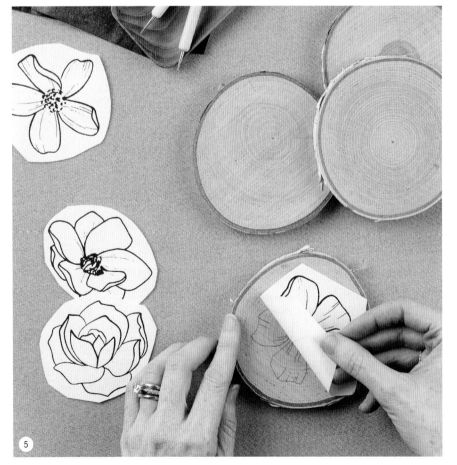

1. Choose your designs and prepare your wooden coasters by sanding them smooth. For this I used birch coasters with a live bark edge.

2. Size, print, cut the designs.

3. Carefully center and place the designs on the wood.

4. Choose your transfer technique (see page 28). For this project blue Chaco, heat, or graphite transfers will work well.

5. Transfer the design to the wood. I used graphite paper with an embossing tool for this step.

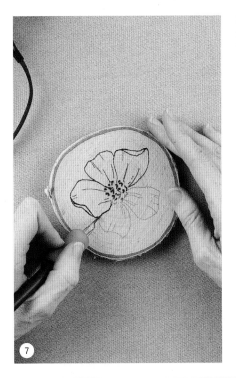

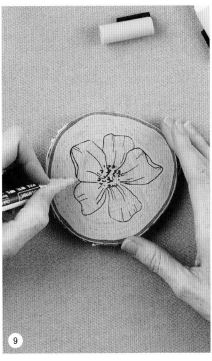

6. Choose a nib that would work best for the design. For these pieces a flow, spade, writing, or shading nib would work well. Ensure it is secure on the burner, and that all safety equipment is in place.

7. Warm up your burner, test the temperature, and then burn the transferred design. If you are using birch wood, you may find that you need to turn up your heat. Go slow and steady. Take your time.

8. Once the full design has been burned, remove any excess transfer lines.

9. Shake up your chalk markers and begin painting. I always start by outlining my designs and edges, so that I can then go back in and fill in without worrying about staying in the lines.

10. Finish your piece with a resin or other water-resistant finish to keep your coasters looking beautiful for a long time. (See page 48 for finishes.)

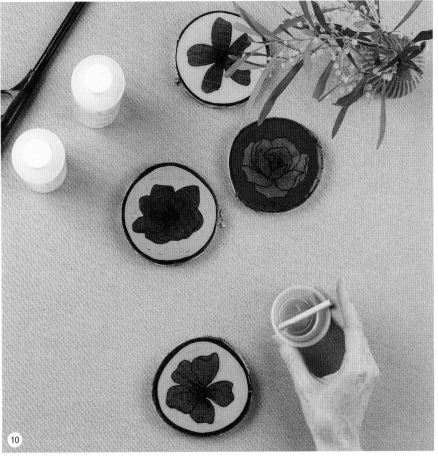

Find design templates at quartoknows.com/page/ WoodBurnBook

# Customizable Wood Burned Borders

*Personalizing Wood Burned Designs with Mixed Media*

## MATERIALS

- Burned Wooden Border
- Glitter + Mod Podge Glue
- Paper Flowers + Hot Glue
- Mirror + E6000 Glue
- Photograph + Scissors + E6000 Glue
- Stickers
- Acrylic Paint + Paintbrush
- Key Hooks + Pencil + Screwdriver
- Plant + Plant Holders

**Alternative Materials:** dried flowers, artificial flowers, shelves, LEGOs, quillings, watercolor, table numbers, lights, gold leafing, embroidery, gemstones, macramé, or whatever else you can dream up.

This section might just be my favorite for its versatility. The frames created by these borders give you a framework, (see what I did there?) to work off of and truly make your own. With these simple border designs, you can customize any wood burned piece to fit your needs. They can be used for birthdays, wedding décor, gifts, home décor, baby shower gifts, anniversaries—you get the idea. I am sure you will come up with ways to use them that I haven't even considered!

Each frame or border is just that—a frame for you to fill, personalize and embellish. The sky is the limit when I think of the possibilities of what could be added to these borders. For this particular piece I have added a mirror, paper flowers, stickers, glitter, a photo, paint, key hooks, and a plant holder. As you can clearly see, each one creates a completely different finished look, even though they all begin the same. I can't wait to see what you come up with!

*"Don't be afraid to mix media!"*

@maxwellwoodshop

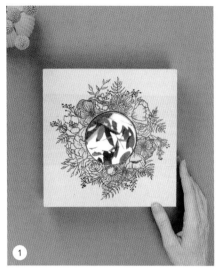

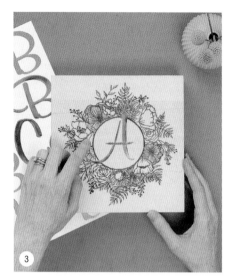

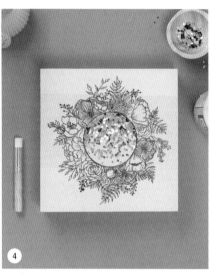

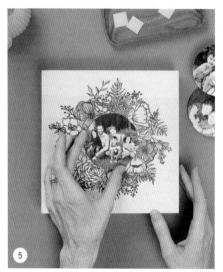

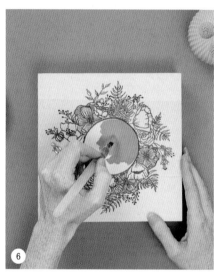

1. **Mirror**—A mirror is a fun and functional item to add to a wood burned border. When using a pre-sized object like a mirror in the center of your border, be sure to size your design to the object before burning the piece. I used a mirror from my local hobby store, and attached it using E6000 glue.

2. **Paper Flowers**—Paper flowers can add a festive, three-dimensional touch to a wood burned border. There are many options available, including making your own. I like to attach these flowers using a hot glue gun, because it is quick and works really well.

3. **Stickers**—A sticker is a simple way embellish a wood burned border. I chose this enlarged letter A, because it has a nice gold shine to it that will really make this piece pop.

4. **Glitter**—Adding glitter to a wood burned border adds whimsy, joy, sparkle, and shine, but it can be a tad messy. I attached the glitter using Mod Podge. It acts like a glue but is also a fabulous finish on a piece. Apply the Mod Podge using a sponge brush, add the glitter while still wet, then finish by adding another coat once dried.

**5** **Photo**—Adding a photograph to the center of a wood burned border is a fantastic and cool technique. Instead of an ordinary frame to display a photo of your loved ones, you can create something truly unique. I attached this photo of my family with some double-sided tape.

**6** **Paint**—Adding color in endless ways, using a variety of different styles (realistic, monotone, abstract, etc.) and mediums can also be a fun way to fill these borders. (See page 42 for adding color options.) You can spray it, splatter it, use your fingers, or apply it with a brush. To protect the burned portions while you add color, I suggest using either masking fluid or painter's tape.

**7** **Key Hooks**—This is a great way to turn your wood burned border into a functional piece of art. A beautiful place to store your keys can be made really easily with just a couple hooks. Measure and mark placement of your hooks with a pencil. Screw the hooks in and voila, a pretty and functional key holder is made.

**8** **Plant Holder**—Adding an air plant to the border, can bring life to the wood burned piece, quite literally. I found this wall mounted air plant holder that was just perfect for this piece. It attaches using a peel-and-stick adhesive. Do not water your plants while they are in the piece as it will cause damage to the wood.

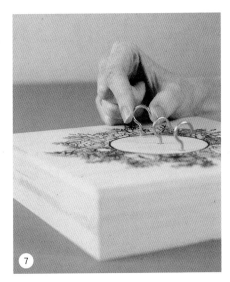
**7**

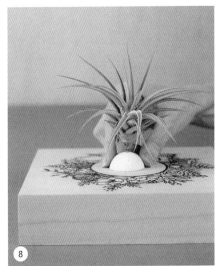
**8**

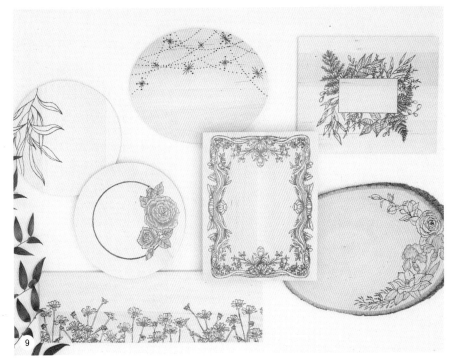
**9**

Instead remove the plant from the wood burned piece, water, and return when mostly dry.

**9** Use this design and these other borders and frames to customize and make your own.

Find design templates at quartoknows.com/page/WoodBurnBook

# ACKNOWLEDGMENTS

Thank you to:

Marc, my wonderful and supportive husband who is there for me through the good and the ugly. I love you.

Abigail, Evelyn, and Isaac, my very patient children who encouraged me to leap when I was scared. You are forever my inspiration.

Myra, for always encouraging me and for always listening with patience.

Tara, my sister, for being such a supportive friend through this.

Mallorie, for being the push I needed to say yes.

Peggy, my mentor, for guiding me in the right direction from the start.

Carrie, my literary agent, for supporting this book.

Jonathan, my editor. This book is far better because of you.

Bessie and Lawrence, my photography team, thank you for your eye.

Anne, Jessi, Lydia, and the whole team at Quarto, for believing in this book.

First Ever Burn Club Retreaters, for your encouragement and support to face this scary duck. It meant the world to me.

And most importantly, my Burn Club community. You all inspire me daily. Thank you for showing up, for believing in the power of community over competition, and for being the reason that all of this is so much fun!

# ABOUT THE AUTHOR

Rachel Strauss is the hands, heart, and mind behind Wood Burn Corner. Rachel found wood burning in 2011 while browsing her local craft store for DIY wedding décor. Its relaxing qualities and beautiful finished look had Rachel hooked.

On Instagram, under her handle @woodburncorner, she hosts events to help wood burning artists from around the globe expand their skills, try new things, and connect with their fellow pyrographers. Wood Burn Corner reflects her love of creating, collaborating, supporting the wood burning community, teaching, and giving back.

Rachel is a firm believer in the idea and spirit of community over competition. She started Burn Club, a place for wood burning artists of all skill levels to gather, share, learn, and grow together. She has hosted in-person wood burning retreats and has online courses to support these artists.

Her artwork can be found on the packaging of the Walnut Hollow Creative Woodburner. Rachel is a featured teacher on Skillshare for her wood burning classes, and her work has graced the official Instagram feeds of Etsy, Joann, Blick, and many others. She has presented at both Altitude Summit and Pinners conferences, and she collaborated with The Crafters Box to create a digital workshop and kit.

Rachel chooses to use wood from sustainable sources and donates to organizations that plant trees around the globe.

She lives and creates in Fremont, California.

# INDEX